IMAGES
of America

MENLO PARK

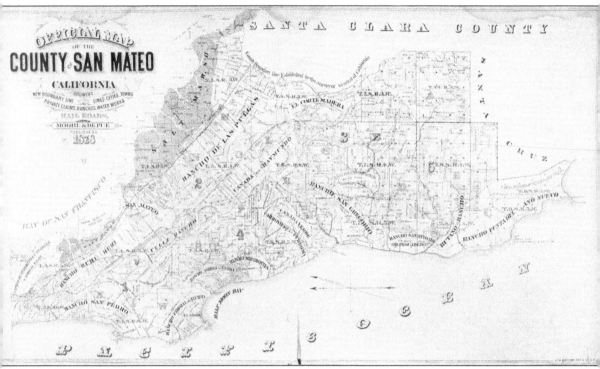

This 1878 map of the southern area of San Mateo County shows Rancho de las Pulgas, which encompassed what is now Menlo Park, Ravenswood (today's East Palo Alto), and Atherton. (Library of Congress.)

ON THE COVER: Completed in 1878, Linden Towers was the palatial country getaway of silver bonanza king James Clair Flood. Nestled on 600 acres along Middlefield Road, the home stood three stories high and was topped with a 150-foot tower. The mansion consisted of more than 40 rooms, each adorned with the finest furnishings from all over the world. The grounds were beautifully manicured by the best gardeners and incorporated large ornate fountains. Flood hosted many lavish galas for the region's wealthy families that had also built beautiful summer homes in the area. (Menlo Park Historical Association.)

IMAGES
of America

MENLO PARK

Janet McGovern, Reg McGovern,
Betty S. Veronico, and Nicholas A. Veronico

ARCADIA
PUBLISHING

Published by Arcadia Publishing
Charleston, South Carolina

Library of Congress Control Number: 2015941625

For all general information, please contact Arcadia Publishing:
Telephone 843-853-2070
Fax 843-853-0044
E-mail sales@arcadiapublishing.com
For customer service and orders:
Toll-Free 1-888-313-2665

Visit us on the Internet at www.arcadiapublishing.com

*For Frank Helfrich, in recognition of his years of dedicated service to the
Menlo Park Historical Association and the Menlo Park community*

CONTENTS

ACKNOWLEDGMENTS

The authors would like to express their gratitude to the following groups and individuals who generously contributed time, photographs, information, and other assistance for this project: Allan Aldrich, Rachel and David Anderson and family, Denise and Bobby Anderson and family, Louis Arenas, Henry E. Bender Jr., Mark Bettencourt, Caroline and Ray Bingham, Claire and Joe Bradshaw, archivist Dr. Jeffrey M. Burns, Archdiocese of San Francisco, the Phillips Brooks School, John Celedon, Jym Clendenin, Patricia M. Constantini, Lydia Dioli Cooper, Anne Warner-Cribbs, Rhonda and Bruce Cumming, Fran Dehn, Mary Dyer (Menlo Park Chamber of Commerce), Mary Claire Draeger De Soto, Richard Draeger, Jack Feldman, Brian Flegel, Frank Fraone and Lindsay Murtha (Menlo Park Fire Protection District), Bill Frimel, Andromeda Garcelon, Cheryl Gehrke and the family of Elmo Hayden (Menlo Camera Shop), Dick Gilberg, Genevieve Grdina (Facebook), John Harder, Frank Helfrich, Diana Beltramo Hewitt, Clark Kepler, Mary Knuckles (Caltrain), Bob Larson (Round Table Pizza), Jim Lewis, Darryl Lindsay, Franz and Kathleen Lorist, Kate McGee and Willie Turner (Hiller Aviation Museum), Lauren Mercer, Clem Molony, Karen Pennington, Carol Peterson, Nicki Poulos, Kathleen Restaino, Dick Roth, Stu Swiedler, Christian Thon and Robyn Sahleen (Menlo Circus Club), Rick Turner, Karen and Armand Veronico, Carrie Viens, Harry Wong, and Plato Yanicks.

The authors would also like to thank the board of the Menlo Park Historical Association for its generosity in supporting this project. This book would not be possible without its guidance and access to its materials.

The majority of the images in this volume came from three main sources: longtime *Redwood City Tribune* photographer Reg McGovern, photographs taken or collected by the proprietor of Menlo Camera, Elmo Hayden, and those provided by the Menlo Park Historical Association (MPHA). The Elmo Hayden Collection (EHC) and the *Peninsula Times Tribune* (PTT) collections are now part of the MPHA.

Readers may also enjoy *Menlo Park: Beyond the Gate* by Michael Svanevik and Shirley Burgett, published by the Menlo Park Historical Association in 2000, and *The Spirit of the Nativity: Christ on the Peninsula for 140 Years*, which was compiled and edited by Rosemary Alva in 2012.

—Janet and Reg McGovern
Betty S. and Nicholas A. Veronico

INTRODUCTION

"Menlo Park is all that its name would indicate, a beautiful park set amidst a grove of trees. Nature was indeed prodigal when it fashioned the section embraced by this thriving community. Not only were many beauties placed there, but a climate was added which makes the place one of rare charm." That is how Menlo Park was described in the 1928 *History of San Mateo County, California 1878–1952*, written by county superintendent of schools Roy W. Cloud. This sentiment still rings true today.

The Santa Cruz Mountains run the length of the San Francisco Peninsula, separating the region into the coast side and the bay side. Menlo Park is located halfway down the bay side of the peninsula and enjoys a temperate climate, shaded from the Pacific Ocean's fog and cool temperatures by the Santa Cruz Mountains. In 1795, the Spanish government granted land in the area to Capt. Don Dario Arguello, the ninth governor of Alto California, who named his parcel Rancho de las Pulgas. The area encompassed 35,240 acres stretching from San Mateo Creek in the north to San Francisquito Creek in the south, the marshlands of the bay in the east, and to what is now Cañada Road in the west. The property passed from Don Dario Arguello to his son Don Luis Arguello and in 1830 to Don Luis's widow, Doña Maria Soledad Ortega Arguello. In 1854, she began selling off parcels of the rancho.

Two transplanted Irishmen, Dennis J. Oliver and Daniel C. McGlynn, acquired more than 1,500 acres along the San Francisquito Creek. The men erected gates at the entrance to their ranch bearing the name Menlo Park, in tribute to the village where they were born—Menlough, County Galway, Ireland. When the San Francisco & San Jose (SF&SJ) Railroad was expanding south, the company elected to put a depot where, at the time, the tracks ended. The closest recognizable feature near the depot was the gates to the Oliver and McGlynn ranch. From this, the train depot, and later the area, gained the name Menlo Park.

On October 17, 1863, construction of the SF&SJ Railroad reached Mayfield (part of today's Palo Alto). To mark the occasion, a special train brought 400 distinguished guests, including California governor Leland Stanford and Oregon governor Addison C. Gibbs, to Mayfield, then back to what is now Menlo Park for a magnificent picnic by the San Francisquito Creek.

In 1867, the train depot was completed; the original building still stands today along the railroad tracks between Oak Grove and Ravenswood Avenues. The town of Menlo Park grew up around the depot, becoming a popular retreat and location for the lavish summer homes of wealthy San Francisco businessmen and their families. Train service reduced the time it took to get to San Francisco to only one hour and 20 minutes, enabling the wealthy to live in Menlo Park and commute to San Francisco for business.

In 1870, the town's first post office opened, followed soon after by Duff and Doyle's general store. Although Menlo Park's population was less than 200, the City of Menlo Park was first incorporated in 1874, with Lester Cooley as the first mayor. Incorporation was a way to raise funds to improve the town's infrastructure. Two years later, incorporation was not renewed, and government of the area passed back to the county.

Jane and Leland Stanford made their summer home in nearby Palo Alto and extensively used the Menlo Park train depot and many of the city's businesses and services. The opening of Stanford University in 1891 brought an influx of students, who availed themselves of all Menlo Park had to offer.

Large estates were constructed east of the railroad tracks and in the northern section of Menlo Park near the border with Redwood City. (This northern section later was incorporated as the Town of Atherton on September 12, 1923.) Silver baron James C. Flood began construction of Linden Towers in 1878 on 600 acres bordering Middlefield Road. When completed, Linden Towers was the largest home west of the Mississippi River.

At the outbreak of America's entry into World War I in April 1917, more than 7,200 acres west of El Camino Real were acquired for a US Army training camp. Construction of the camp, named in honor of Maj. Gen. John C. Fremont, began on July 24, 1917. National Guardsmen from Idaho, Oregon, Washington, and Wyoming came to Camp Fremont to learn skills from target practice to hand-to-hand combat. With the Army came improvements in the area's civil infrastructure, which included the installation of sewers, water and gas service, paved streets, streetlights, railroad spurs, and everything the Army would need for a training camp. The influx of soldiers with money to spend brought new merchants to El Camino Real, many of which stayed in the area after the camp closed in December 1918.

Today's veterans' hospital on Willow Road began as the base hospital for Camp Fremont. In 1922, the hospital was transferred to the US Veterans Bureau, and the temporary World War I–era buildings were replaced by newly constructed facilities.

World War II saw servicemen and women back in Menlo Park at the new Dibble Army Hospital. The Hopkins estate, on 300 acres situated between the railroad tracks, Middlefield and Ravenswood Avenues, and San Francisquito Creek, was torn down and a 2,700-bed hospital erected on the grounds. Injured soldiers returning from the Pacific theater were transported from the battlefield to San Francisco and then down the peninsula for treatment. Many pioneering plastic surgery techniques were used to help wounded soldiers heal.

In the postwar years, Stanford Research Institute (SRI International) and the US Geological Survey (USGS) occupied the land and many of the buildings of the former Dibble Army Hospital. SRI is an independent research laboratory providing research, technology development, verification, and validation services to government and industry customers. An SRI spinoff that is most recognizable is the Apple iPhone's intelligent personal assistant, Siri, which was developed at SRI's International Artificial Intelligence Center.

The USGS campus on Middlefield Road is the agency's largest facility in the western United States and now encompasses the Earthquake Science Center. More than 600 scientists work in a variety of water-, earth-, and biology-related disciplines from geology (plate tectonics was discovered here in the 1960s) to water resources and climate change. In the 1960s, the City of Menlo Park built a new civic center near both SRI and USGS on former Dibble Hospital land.

Along Sand Hill Road on the west side of Menlo Park, construction of the SLAC (Stanford Linear Accelerator Center) National Accelerator Laboratory began in 1962. The accelerator is two miles long and stretches under Highway 280. In the facility, electrons and positrons are accelerated to high energy for particle and photon physics experiments.

Menlo Park's proximity to Silicon Valley saw the city become home to one of the highest concentrations of venture capital firms in the United States. More than 40 venture capital firms are located along a two-mile stretch of Sand Hill Road from Santa Cruz Avenue to Highway 280. These companies took the risk to fund entrepreneurs whose business concepts were leading edge at the time, and they are now household names such as Apple Computer, Electronic Arts, Facebook, Google, LinkedIn, and many others.

Menlo Park's retail business district stretches from the railroad tracks west past El Camino Real and down Santa Cruz Avenue. The downtown area is filled with shops and restaurants and is pedestrian-friendly; although the city is home to many large corporations and government agencies, Menlo Park retains the feel of a small town.

One

THE EARLY YEARS

Menlo Park, once a vast, picturesque area inhabited by the Ohlone Indians, began to see growth, mostly in summer homes for the wealthy, in the mid-19th century. People were drawn to the area for its beauty and tranquility, a sharp contrast from the city life most of them lived in San Francisco. With only dirt roads between San Francisco and Menlo Park, many of them impassable during the rainy season, city dwellers were only able to establish summer homes in the area.

As the train tracks from San Francisco to San Jose were laid and travel to Menlo Park improved, the wealthy began to pour into the area. Some of the early, affluent residents who made their summer homes, and eventually their residence, in the Menlo Park area were the Atherton, Doyle, Flood, Hopkins, Latham, Meyer, O'Keefe, and Selby families.

While the homes were owned by the wealthy, several immigrant groups owned and ran local businesses that supported the large estates. The majority were Irish immigrants, most escaping the potato famine in their homeland. Then, in the late 1800s through the early 1900s, the Chinese immigrant population grew as they sought opportunities as construction workers for the railroad and nearby Stanford University. By the 1930s, the majority of the Chinese families left Menlo Park for other parts of the San Francisco Peninsula.

As the city grew, plans were developed to reincorporate. Menlo Park's representatives wanted to maintain the boundaries as they were previously laid out in the first incorporation, which included Fair Oaks (now Atherton) and Ravenswood (now East Palo Alto), but the large landowners in Fair Oaks wanted to keep their area residential, without businesses. After much debate, the race to the courthouse was on. In September 1923, the representative from Fairs Oaks presented paperwork to incorporate, only to discover that the name was already taken by a town near Sacramento. It was decided to name the city after one of the first settlers in the area, Faxon Dean Atherton. Four years later, on November 23, 1927, Menlo Park incorporated as a city without Atherton or Ravenswood.

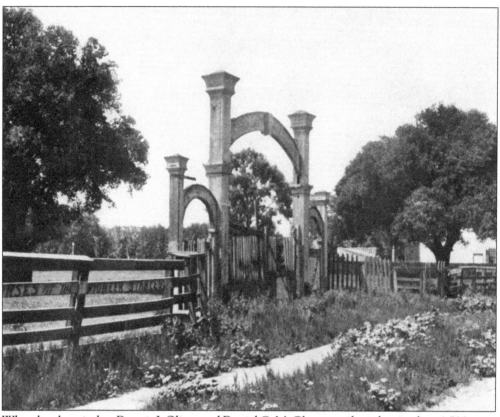

When brothers-in-law Dennis J. Oliver and Daniel C. McGlynn purchased more than 1,500 acres from Rancho de las Pulgas in 1854, they built a massive arched gate to mark the entrance to their property. At the top of the larger center arch were the words "Menlo Park" in 12-inch white letters. The Irish immigrants named the property after their hometown Menlough, a village in northeast County Galway, Ireland. The gate was destroyed in 1922 by a reckless driver. (MPHA.)

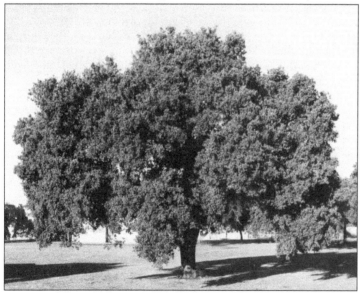

The beauty of the oak trees and natural vegetation beckoned the wealthy from the city to build magnificent summer homes in Menlo Park. The area was once home to ancient forests of oak and other species of trees. As the settlements grew, the forests diminished, but the oak tree is still prevalent in this beautiful city. The live oak is part of the official Menlo Park logo. (MPHA/EHC.)

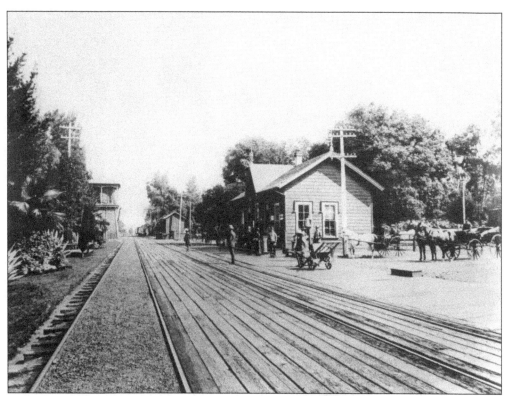

In 1867, the Menlo Park train depot, pictured
here around 1885, was completed. It included
a ladies waiting room on the south side, a
general waiting room on the north side,
and the stationmaster's office in the middle.
Looking south, the train, barely visible,
is heading to the station as people on the
platform and in carriages await its arrival.
On the left of the tracks is the 20,000-gallon
water tower that serviced the steam engines.
It stood for about 35 years, until it fell across
the tracks, flooding the area and taking
down the telegraph wires. (MPHA.)

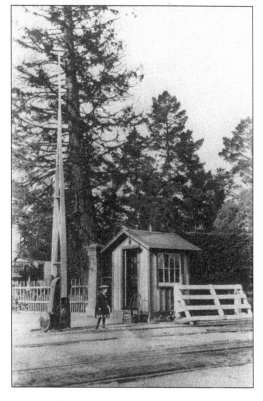

This small guardhouse at the Oak Grove
Avenue railroad crossing was located
on the north end of the railway station
and situated on the Menlo Park Hotel's
property. With the crossing guard not at
his post to lower the arm, the little girl
had to look very carefully up and down
the track before she crossed. (MPHA.)

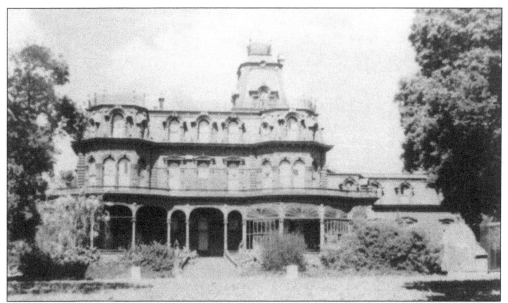

This 40-room mansion, built by William E. Barron in 1864, was nestled on 280 acres on what is now Ravenswood Avenue. In 1871, Milton S. Latham purchased the home for $75,000 and named it Thurlow Lodge. After losing his fortune in the depression of 1883, Latham sold the property to Mary Francis Sherwood Hopkins, widow of railroad builder Mark Hopkins, who in turn renamed it Sherwood Hall. In 1888, she gifted the property to her adopted son Timothy Hopkins. Upon Hopkins's death, his widow sold the property to the US government, and it become Dibble General Hospital. During Latham's ownership, he traveled throughout Europe and purchased many elaborate and ornate fountains that he placed on the property. When the estate was converted to the hospital, the gatehouse and this fountain, below, survived the wrecking ball, and they can be seen at 555 Ravenswood Avenue. (Above, MPHA; below, MPHA/PTT.)

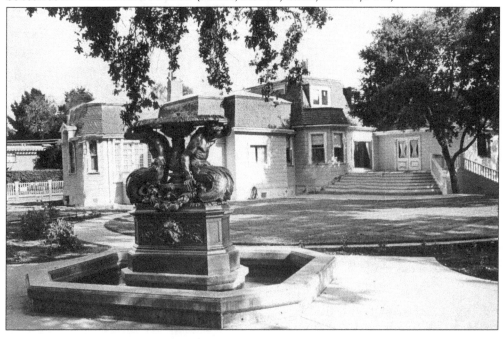

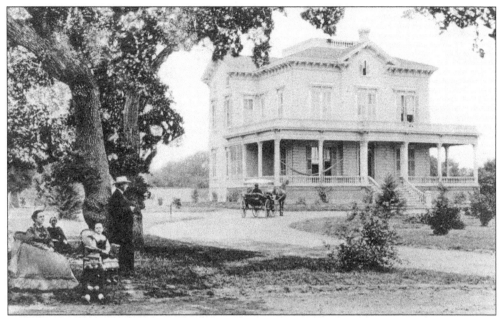

Holm Grove, the home of prominent banker Joseph A. Donohoe, was built in 1868 on Middlefield Road and Ringwood Avenue, where Donohoe and his wife, Emilie, raised their three children, Mary Emilie, Joseph A. Jr., and Edward. Five generations called the estate home, including the first mayor of Atherton. In 1949, the Donohoe family sold the property to the City of Menlo Park for $141,105, and it became the new home of Menlo-Atherton High School. (MPHA.)

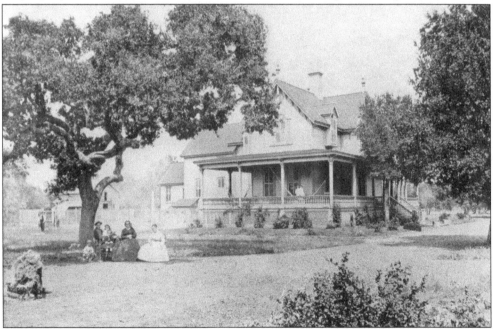

Set on a beautiful oak-studded parcel, Ringwood was the two-story home of John T. Doyle. The son of Irish immigrants, Doyle went on to become a well-respected San Francisco attorney. The home was completed in 1868, and he and his wife, Antonia, raised five sons and three daughters there. (MPHA.)

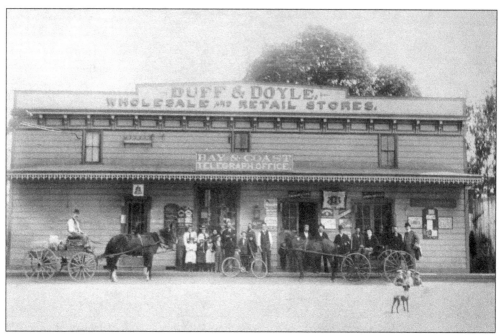

Doyle's general store opened on the corner of Santa Cruz Avenue and County Road (now El Camino Real) in 1874 and soon became a focal point of Menlo Park. Later, the store became Duff and Doyle after James Doyle added Michael Duff as a partner. Shown here is the original two-story wood structure with employees and patrons in front. (MPHA.)

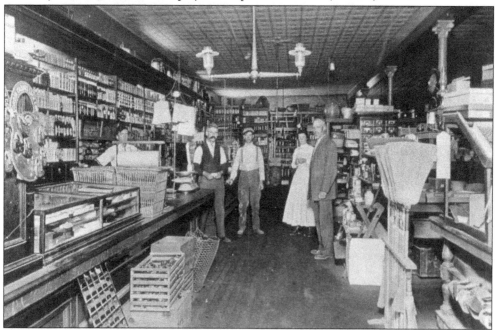

The interior of Duff and Doyle was filled with everything from fine silk to blasting powder. A dance hall and meeting rooms were upstairs. Shown here are employees of the store, including Susan Gale, who was the bookkeeper at Duff and Doyle before she moved on to her career in banking. (MPHA.)

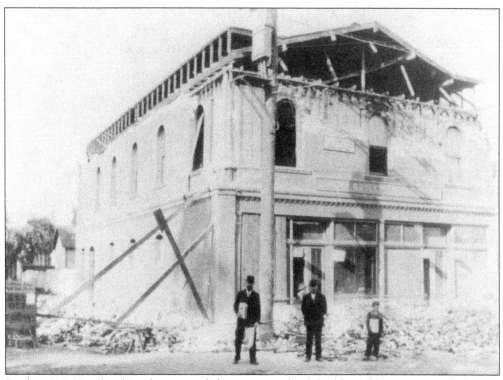

By the 1890s, Duff and Doyle occupied this two-story brick building. The structure was heavily damaged in the 1906 earthquake. Pictured here is the damage, with William Doyle (left) standing out front along with Joe Kelly selling the day's paper with news of the earthquake's devastation. The building was quickly repaired and business resumed until the early 1920s, when the company was liquidated. (MPHA.)

After Duff and Doyle moved out, the building was occupied by Menlo Grocery for many years. The upstairs of the building served as a dance hall and was used by the Masonic lodge. Note the F&AM (Free and Accepted Masons) sign, on the front of the building. The structure was demolished in 1942 to aid in the widening of El Camino Real. Menlo Grocery then moved to a new location south of Oak Grove Avenue on El Camino Real. (MPHA.)

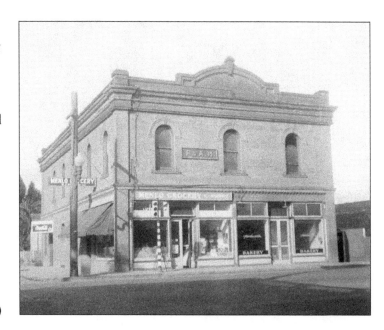

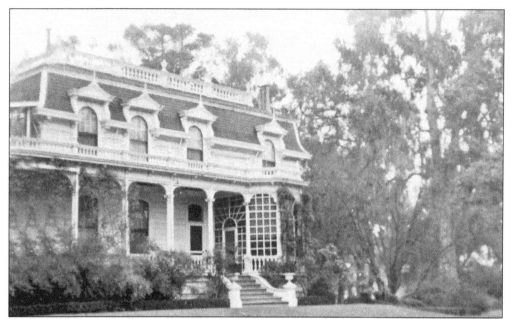

Elmwood, the beautiful 1875 Victorian summer home of Charles Holbrook, was located on 22 acres at 150 Watkins Avenue between El Camino Real and Middlefield Road. Upon Holbrook's death in 1926, the home went to his daughter Olive Holbrook-Palmer and her husband, Silas. They continued to use the home as a summer retreat until Olive's death in 1958, when Elmwood was willed to the city (now Atherton) and became the Holbrook-Palmer Park. (MPHA.)

This 21-room home at 1040 Noel Drive is reportedly the third-oldest building in Menlo Park. Originally built as a summer home for T. Lemmon Meyer in 1869, the structure has served many purposes over its life, including a gambling hall, an officer's club for Camp Fremont, a military academy, several hotels (shown as Marie Antoinette Inn in the 1960s), and an antique parlor and tea room, when it was given the name Bright Eagle. Today it serves as offices. (MPHA/PTT.)

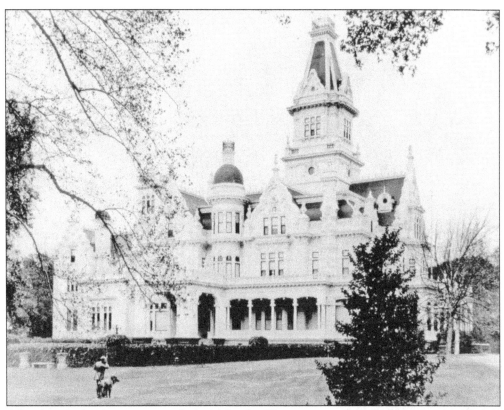

After three years of construction, the lavish Linden Towers, situated on 600 acres along Middlefield Road, was completed in 1878. Owner James Clair Flood spent a considerable amount of his Comstock silver-mining fortune ensuring the house, its furnishings, and the grounds were appointed with the finest things money could buy. Flood only lived in the grand estate until his death in 1889, when it was inherited by his daughter Jennie Flood, who then donated it to the University of California. (MPHA.)

Linden Towers was a wonderful place to entertain, and James Flood was an extraordinary host to the elite of the area. He regularly hosted extravagant parties for many prominent pioneer families, including the Athertons, Stanfords, Hopkinses, Donohoes, and Lathams, just to name a few. Shown here are some of the guests relaxing on the grounds of the beautiful estate, with the grand home in the background. (MPHA.)

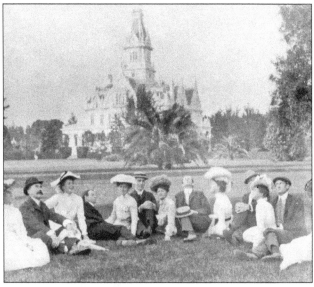

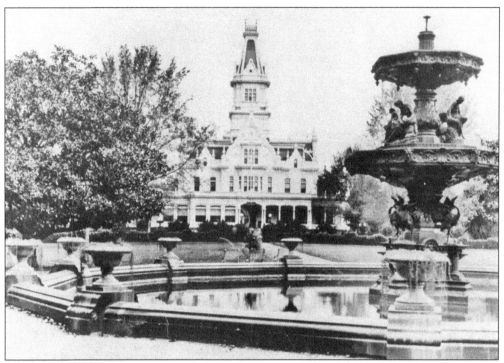

The magnificently manicured grounds of Linden Towers were once graced by three elaborate fountains, the largest of which is shown here. The cast-iron fountain stood three tiers high with beautiful cast-zinc figures at each tier. The base was a 12-sided, 60-foot-wide basin with cast-iron urns at each angle. This fountain survived destruction and still stands in its original location, which is now 42 Flood Circle. (MPHA.)

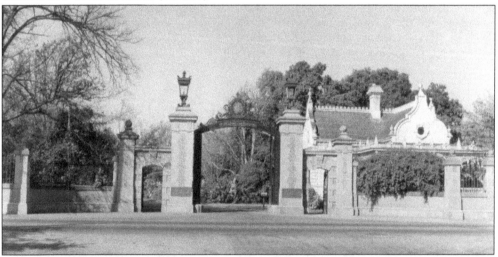

The contents of Linden Towers were sold at auction in 1934, and the home was dismantled shortly thereafter. Many of the artifacts, including the three-tiered fountain, streetlights, urns, and benches, were relocated to each of the subdivided parcels. The beautiful gates to Linden Towers also survived and stand today on Middlefield Road. Behind the gates where the once magnificent "White Castle" once stood is now Lindenwood, a maze of tree-lined streets and more than 400 beautiful homes. (MPHA.)

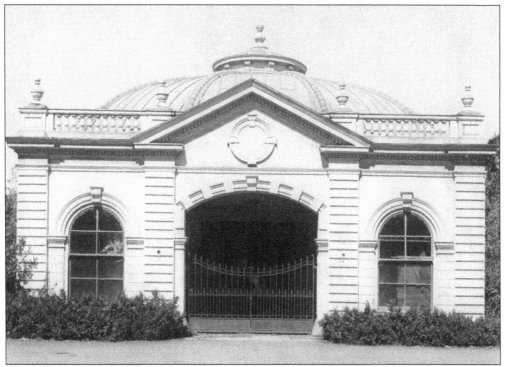

In 1904, James L. Flood, son of James C. Flood, purchased the old family home when the University of California decided the upkeep was too daunting. As with all aspects of the Flood estate, James L. added this beautifully appointed garage and a mechanic's shop to the property. He also replaced the old mine-cable fence with a new brick wall that still runs along Middlefield Road. The garage itself was a magnificent structure with a domed roof to house Flood's collection of the time's finest automobiles. (Both, MPHA.)

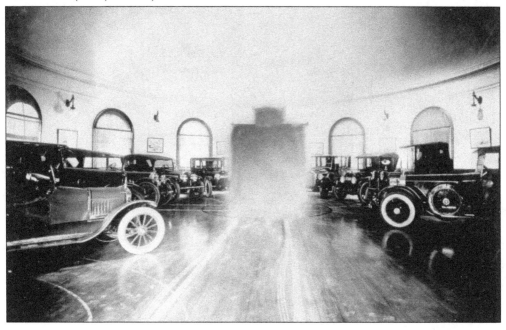

19

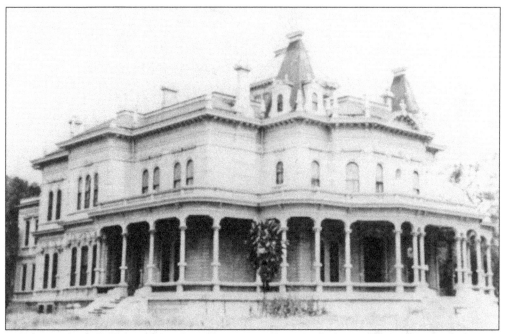

Maria O'Brien Coleman purchased a 165-acre parcel in 1878 and commissioned Augustus Laver, the architect of Linden Towers, to design this 22-room Italianate mansion. Taking two years to build at a cost of $100,000, the home was to be a wedding gift for her son, state assemblyman James Valentine Coleman, and his bride, Carmelita. But in the early hours of June 8, 1885, Carmelita was fatally shot in their San Francisco home. After a hasty investigation, her death was deemed an accident. Coleman sold the home in 1905 to Livingston Jenks, who subdivided the land and allowed seminarians to use the home from 1906 through 1919, after their dormitories were destroyed by the 1906 earthquake. Humanitarian Josephine Duveneck purchased the home along with 10 acres in 1929 for $26,500 to house the Peninsula School. (Both, MPHA.)

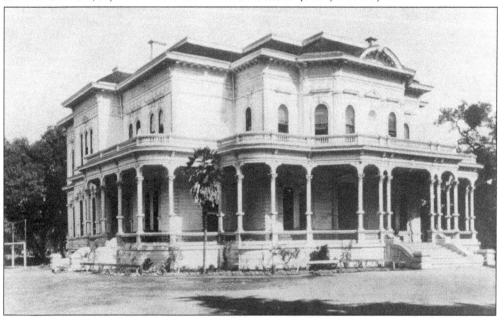

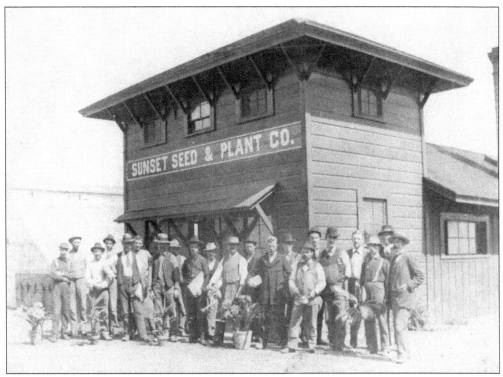

While Menlo Park was renowned for its beautiful countryside, the formal gardens of the lavish estates required exotic plants, shrubs, and trees. Michael Lynch, an Irish-born graduate of the Royal Botanical Gardens of Dublin, became Menlo Park's premier horticulturist. Upon his arrival in California, he first worked for Faxton Atherton, then for James C. Flood, maintaining the formal gardens at Linden Towers. After Flood's death in 1889, Lynch went to Sherwood Hall to maintain the grounds for Timothy Hopkins. There a nursery was established that employed 60 Chinese workers, which later became known as the Sunset Seed and Plant Company. In 1892, Lynch set out on his own, establishing the Menlo Park Nursery on Oak Grove Avenue, where he built 15 greenhouses and continued his service to the homes and city. (Both, MPHA.)

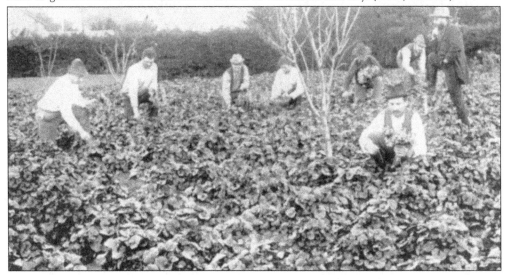

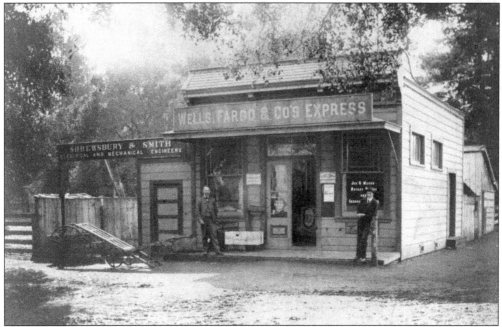

Located near the depot, Wells Fargo & Company's Express of Menlo Park shared a building with Shrewsbury & Smith, electrical and mechanical engineers. The building also housed James G. Mason's Notary Public and Insurance Company. Standing in front of the building around 1890 are James Mason (left) and Matt McCullough. Mason also served on the Menlo Park School Board for 18 years. (MPHA.)

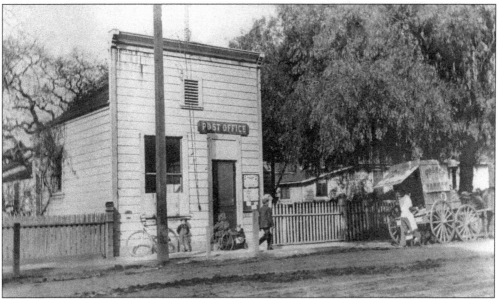

The Menlo Park Post Office building, located on Golder Lane (now Santa Cruz Avenue), was constructed in 1892. Jane Loveland became the first female postmaster in the state when she was appointed by Sen. Leland Stanford. Upon Loveland's retirement, she was given the building. The structure was moved a couple blocks west, where Loveland made it her home. To the right is the Palace Market meat wagon, where local housewives would go to purchase meat. (MPHA.)

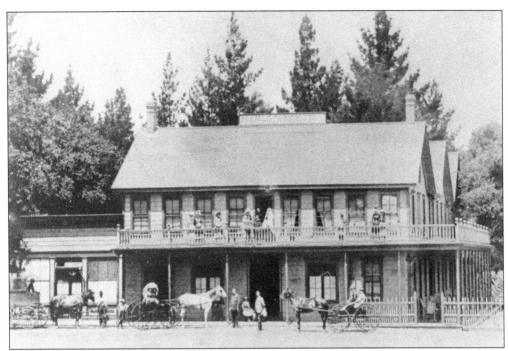

In 1868, brothers Diedrich and Martin Kuck built the Menlo Park Hotel on Oak Grove Avenue, across from the train depot, to accommodate the influx of people traveling to the area for vacation. The hotel served meals, housed a general store, and was surrounded by picnic areas with beautiful flower gardens. Guests could also use the horses and carriages from the hotel's stables. A fire severely damaged the hotel in 1896, but most of the furnishings were salvaged, and the hotel was quickly rebuilt. (Both, MPHA.)

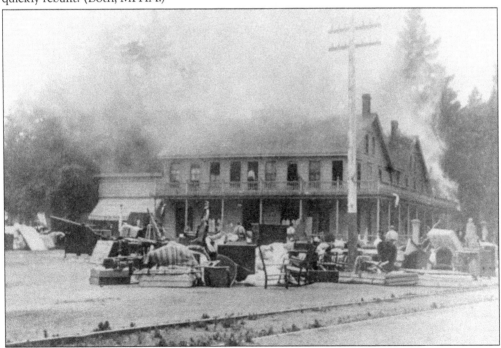

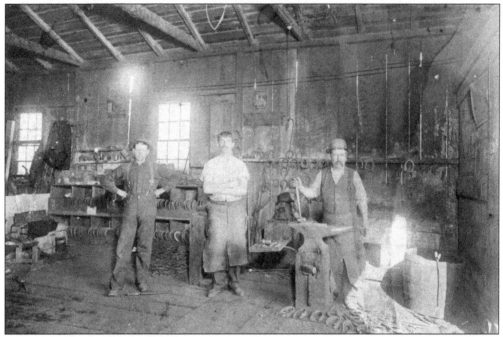

Frank Roach owned one of the premier blacksmith shops in Menlo Park. The interior of the shop and three of the blacksmiths are pictured here about 1898. (MPHA.)

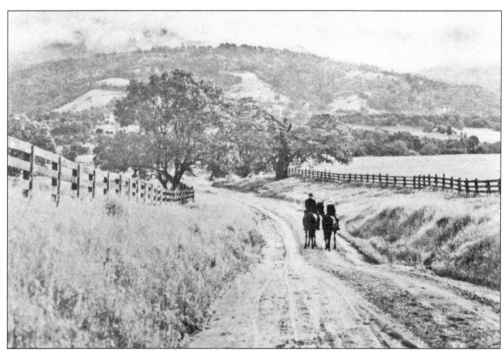

The now-bustling, world-renowned Sand Hill Road was once just a dirt path where horses and buggies were the mode of transportation. This 1904 photograph, looking westward with the Pacific Ocean just over the cloud-covered mountains, depicts the once quiet and peaceful Sand Hill Road. (MPHA.)

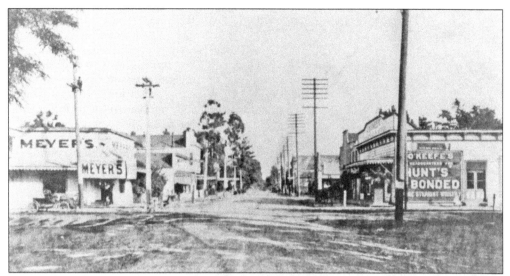

At one point, before Prohibition, the town reportedly had 14 saloons and a bar in each of the three hotels. Looking south on El Camino Real at Oak Grove Avenue, this photograph taken between 1907 and 1909 shows two of the town's largest saloons, Meyer's, on the southeast corner, and O'Keefe's, just across the street. (MPHA.)

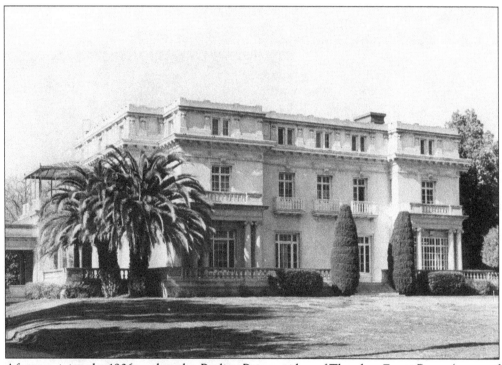

After surviving the 1906 earthquake, Pauline Payne, widow of Theodore Fryatt Payne (owner of Payne Bolt Works of San Francisco), wanted a home that would withstand any future quake. At a cost of more than $1 million, she commissioned this beautiful concrete 52-room Italian-style villa, located at 2128 Valparaiso Avenue. After many setbacks, Payne moved into the home in 1914. It still stands today, serving as the administration building for the Menlo School. (MPHA.)

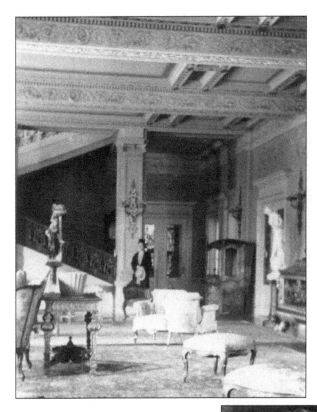

With large rooms to fill, including eight master suites, Pauline Payne scoured Europe, securing the best furnishings, paintings, and sculptures possible for her lavish home and exquisite gardens. The stairway, seen in the background, was made of imported Italian marble, the floors were hardwood parquet, and paneling was all imported woods. (MPHA.)

In 1921, inventor Leon F. Douglass purchased the Payne home for $600,000 and renamed it Victoria Manor, after his wife. Prior to moving to Menlo Park, Douglass patented and sold millions of the hornless Victrola, again, named after his wife, Victoria. He converted a portion of Victoria Manor into a laboratory and continued his experiments in radio and television. Douglass registered 50 patents for his inventions, 24 of which were submitted while he lived in Menlo Park's Victoria Manor. (MPHA.)

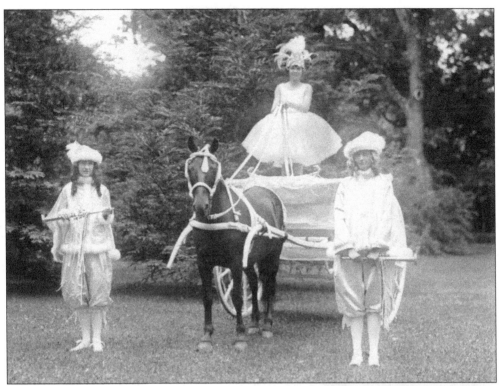

In 1920, a group of young girls held a circus for their family and friends at the W.B. Weir estate on Middlefield Road and Glenwood Avenue. The girls included their ponies, horses, cats, goats, and other pets in the circus. The first year they raised $500, which was donated to the Stanford Convalescent Home, now Lucille Packard Children's Hospital. The second year grew larger with the assistance of adults promoting it. By the third year, 1922, the circus had grown so large that land was purchased, establishing the Menlo Circus Club. "Polly of the Circus and her Heralds" are, from left to right, Catherine Stent, Louise Hahn on the carriage, and Nancy Merrill, preparing to take the stage. At right, standing on the backs of their beautiful horses are, from left to right, Dana Dumphey, Rowena Dumphey, Sibyl Coryell, and Evelyn Taylor. Now officially located in the town of Atherton, the Menlo Circus Club has evolved into a highly regarded family club for equestrians, polo matches, tennis tournaments, and social events. (Both, Menlo Circus Club.)

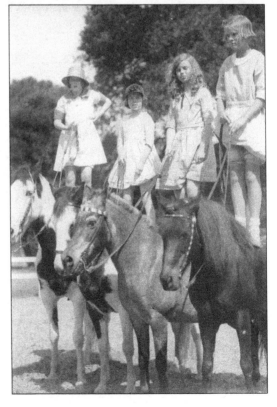

Built some time before 1846, this 13-by-30-foot adobe building is believed to have been constructed as a shelter for the vaqueros of Rancho de las Pulgas. It was located in the Menlo Oaks area at 1060 Colby Avenue. By 1956, the area was preparing for development, and the adobe was slated for demolition. To prevent its destruction, John Wickett purchased the old structure and obtained permission from various agencies to move the building to his 3,500-acre property on Skyline Boulevard, above the town of Woodside. The adobe was loaded onto a trailer and carefully driven to its new home overlooking Skagg's Point, where it still stands today. (Both, MPHA.)

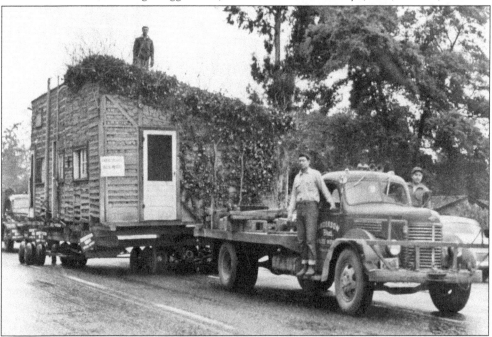

Two

THE FUNDAMENTALS
EDUCATION AND FAITH

As Menlo Park's early residents began assembling the essential elements of a good community, churches and schools were among the first institutions established. The devout Dennis Martin set the pattern, building his own family church, which was the first Catholic church in San Mateo County. Neighborhood children were invited to attend class on weekdays with Martin's nine children. Two decades later, the Church of the Nativity opened its own doors to Kate Sullivan, who taught school to Menlo Park children.

The pioneers did not seem to get mired in denominational differences or separation of church and state. Jane Stanford donated funds at a critical time for the First Presbyterian Church, but the Leland Stanfords, though not Catholic, also provided vital water access to allow St. Patrick's Seminary to go forward. Until a chapel could be built, the Episcopal congregation was able to hold services in the Menlo Park School, and when the city's grammar school burned down in 1912, students attended class at the Presbyterian church. The same community spirit was still alive and well in 1946, when that church needed to raise $9,000 for its share of a new city parking district assessment, a huge sum compared to $11,000 in yearly offerings. A community citizens committee with members from the Episcopal, Lutheran, and Roman Catholic churches went door-to-door to raise the funds vital to Menlo Park Presbyterian Church. Some of the first churches, and later ones like St. Raymond's Parish, have opened their own schools.

The Phillips Brooks School, on the other hand, had roots in the Episcopal church but is no longer religiously affiliated, while the Peninsula School, which opened in the former Coleman mansion in 1925, was a pioneer in offering an alternative education. In public schools, the end of World War II set off a wave of school building and expansions, including a drive that led to the 1951 debut of Menlo-Atherton High School, serving the families of those neighboring cities. Both take great pride in "M-A," which has set an enviable record of achievement in every field, from academics to arts and athletics.

In 1853, Irish immigrant and pioneer lumberman Dennis Martin built a church for his family and neighbors near present-day Stanford Linear Accelerator Center. Blessed in 1856, St. Denis Church also served as a school and had a small cemetery nearby. In 1864, Martin lost most of his land in a title dispute. After he died in 1890, Martin was reputedly buried at St. Denis Cemetery. (Janet McGovern.)

After the dispossessed Martin family had departed, the church fell into disrepair. In 1953, Stanford University, which owned the St. Denis land, ordered the exhumation of the remains. Records for 174 graves were found, but the remains of only 24 were located when they were exhumed. On February 12, 1953, a ceremony marked the occasion of the reburial of the remains at Holy Cross Cemetery on Santa Cruz Avenue. (Reg McGovern.)

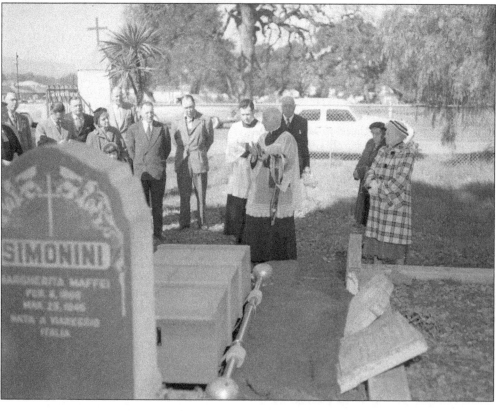

California's first bishop blessed the Church of the Nativity as a new parish in 1872, and the first church was a tiny structure on the southeast corner of Ringwood Avenue and Middlefield Road. The Church of the Nativity had to be moved in 1877, first to Santa Cruz Avenue and finally to 210 Oak Grove Avenue, where it stands today—a beautiful landmark of faith. (MPHA.)

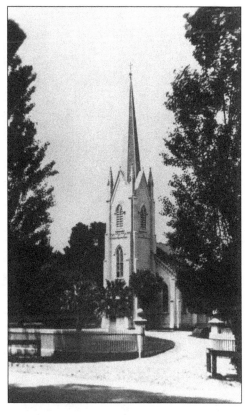

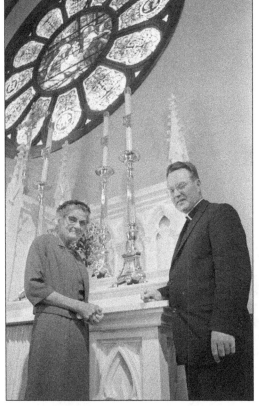

City historian Susan Gale is pictured here in 1966 at the Church of the Nativity with Fr. William M. Lenane before a crucifix and six silver candlesticks that had been blessed by Pope Pius IX about 110 years earlier. The artifacts had originally been shipped from France for St. Denis Catholic Church. After lumberman Dennis Martin lost most of his land, the treasures were eventually relocated to the Church of the Nativity. (Reg McGovern Collection.)

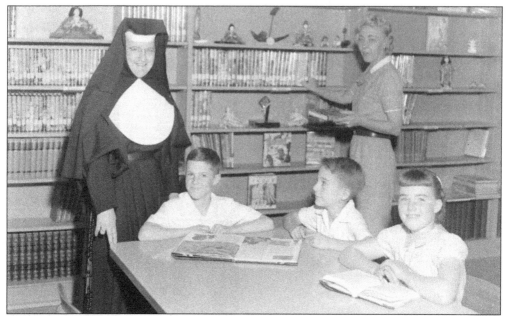

With the postwar baby boom, Church of the Nativity parishioners responded eagerly to a campaign to raise funds to build a parish school. Staffed by the Presentation Sisters, the school at the corner of Oak Grove Avenue and Laurel Street opened for the 1956 school year, enrolling children in kindergarten through fourth grade. A new grade was added every year. The Nativity School library is shown in this 1957 photograph. (Reg McGovern.)

Nativity could not handle the baby boom onslaught by itself, and St. Raymond Parish was established in 1950 on 11 acres that the Archdiocese of San Francisco purchased on Santa Cruz Avenue at Arbor Road. The Catholic school's doors opened in 1954, but St. Raymond Church did not open until 1959. This photograph of the church at 1100 Santa Cruz Avenue was taken when it was completed. (Reg McGovern.)

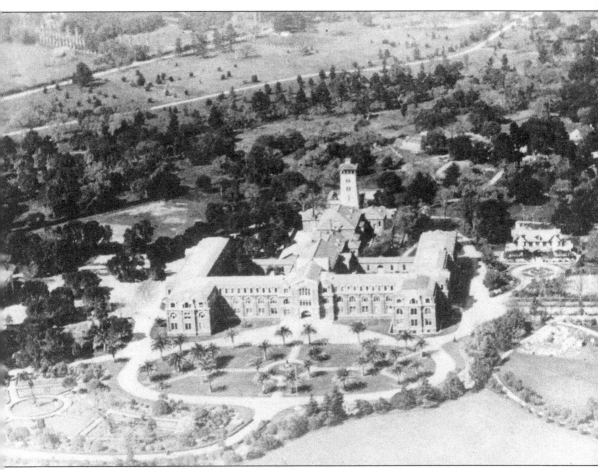

In 1850, Joseph Sadoc Alemany arrived in San Francisco to become California's first bishop. He was committed to the establishment of a seminary where priests could be trained as local clergy, but despite two attempts, the dream was not realized during his lifetime. His successor, Archbishop Patrick Riordan, visited Rome in 1888 and sought approval—which he finally won—for staffing by Sulpician priests, who devoted themselves to training future priests. He then secured seed money for a seminary from several wealthy benefactors. The final piece—a location—fell into place when Kate Johnson, the widow of Rupert Johnson, donated 83 acres in Menlo Park. The Leland Stanford family provided access for a water supply, and Jane Stanford donated funds for a chapel. Though about two-thirds complete, the seminary opened in 1898. Archbishop Riordan presided over the first commencement the following year. Development continued, and in 1904 construction began on the chapel and the east wing. This photograph was taken after reconstruction following the 1906 earthquake. (Archives of the Archdiocese of San Francisco.)

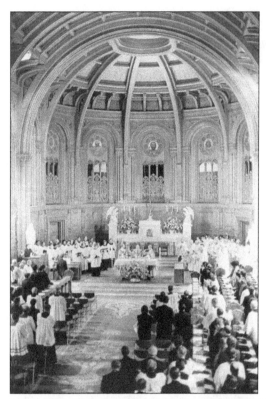

The St. Patrick's Seminary chapel was almost complete when the 1906 earthquake struck. The seminary's architectural and spiritual center, the chapel was enlarged during the reconstruction, and windows were added. Completed in 1918, this majestic chapel is shown in an early-1970s photograph during a ceremonial occasion. The assembly sits in longitudinal rows of oak stalls, divided by a 70-foot-long carpet. (Archives of the Archdiocese of San Francisco.)

Everybody likes to get mail, and these late-1950s seminary students hoping to receive a letter from home were no different. Then, as now, students at the institution—called St. Patrick's Seminary and University—are engaged in intensive studies for four or more years, community and personal prayer, and leisure activities, including sports. It is all in preparation for the mission of ordination as priests. (Archives of the Archdiocese of San Francisco.)

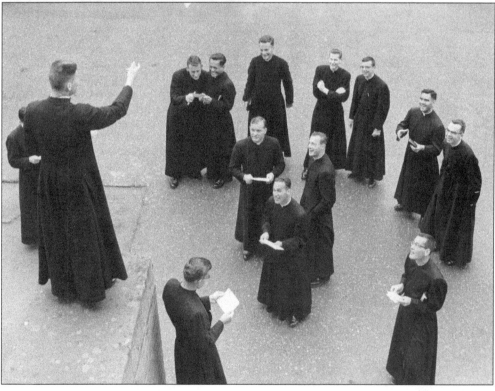

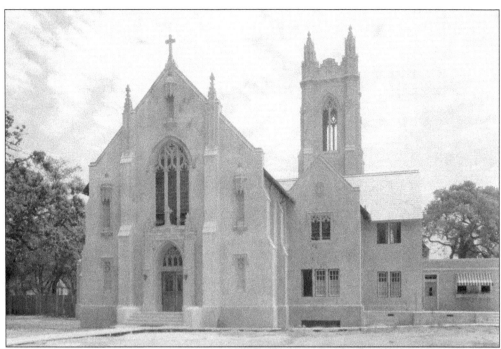

Located at 215 Oak Grove Avenue near the Church of the Nativity, the Corpus Christi Monastery was established in 1928 on land once owned by pioneer nurseryman Michael Lynch. The monastery is home to nuns from the Dominican order and was founded in response to a desire for a contemplative monastery whose purpose is to honor and promote devotion to God. Set back from a busy street, Corpus Christi Monastery is also set apart spiritually as a place of serenity and reassurance. The Dominican nuns are cloistered religious who pray for the world, distribute altar bread hosts to local churches, and work within the monastery. The nuns gather seven times a day for liturgy, prayer, and adoration of the blessed sacrament. The public is welcome to visit the chapel during the day. (Above, MPHA; right, MPHA/PTT/Sam Forencich.)

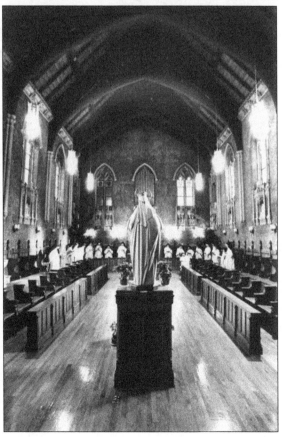

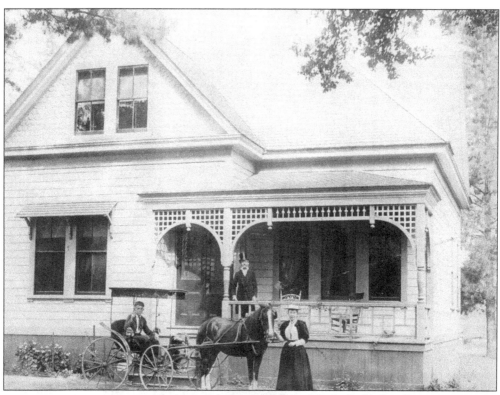

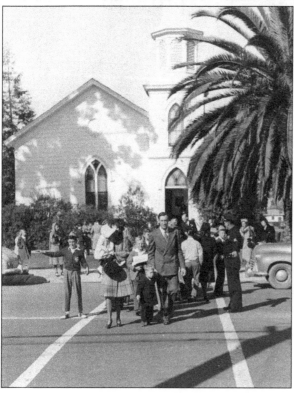

Menlo Park's first Protestant church—the Menlo Park Presbyterian Church—was organized in 1873. The next year, land for a building at 700 Santa Cruz Avenue was donated, and it was completed in January 1875 at a cost of $4,000. Many of the area's wealthiest residents worshipped there, and it was dubbed the Church of the Pioneers. Jane Stanford was an early benefactor, paying for repairs, an organ, and hymnals. The redwood building had a Gothic facade and a white steeple. In the 1893 photograph above, the minister and his family are outside the manse. Today this home is on Arbor Road next to Jack W. Lyle Park. Pictured on the left in the late 1940s, a family walks across Santa Cruz Avenue, a charming image indeed with the church in the background. (Both, Menlo Park Presbyterian Church.)

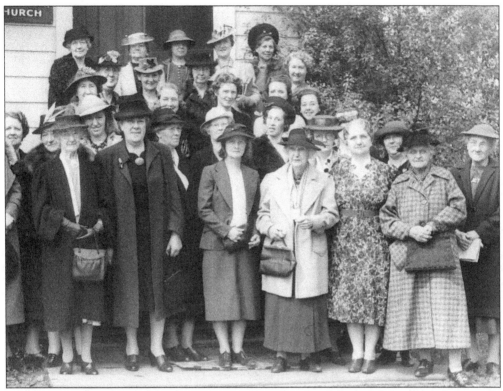

When these women smiled for the camera in 1941, the church had already survived almost 70 years. They would undoubtedly have been pleased at how Menlo Park Presbyterian Church has grown since World War II. In 1950, the church moved two blocks west to the present site at 950 Santa Cruz Avenue, and it grew to serve more than 2,100 members by its centennial in 1973. The sanctuary enlargement was completed in 1970, and a stained-glass window was installed. Growth accelerated in the 1970s, and multiple services, outreach programs, and ministries were added. In 2007 and 2008, the church spawned campuses in San Mateo and Mountain View. With nearly 4,000 members, Menlo Park Presbyterian Church was listed 17th among the 50 most influential churches in America in a 2007 survey. (Above, Menlo Park Presbyterian Church; below, Reg McGovern.)

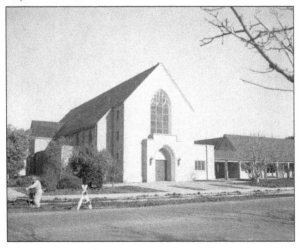

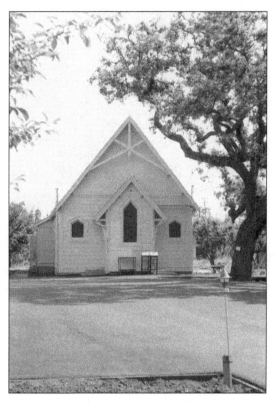

Dedicated in 1886, the original Trinity Episcopal Church has had a complicated history. Located first on Encinal Avenue, the simple redwood building, pictured here in 1958, was moved twice before the Episcopalian church outgrew it. The Menlo Park Russian Orthodox congregation, which had been meeting there, moved it yet again in 1957. Today, the Nativity of the Holy Virgin Church is located at 1220 Crane Street. (Reg McGovern.)

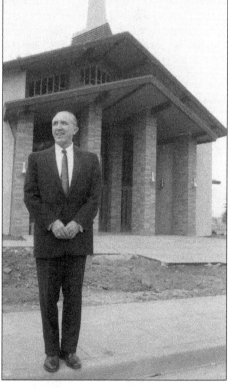

Prior to 1949, Baptists met at a funeral home and city hall before they were able to build their own church at Middle Avenue and Arbor Road on 1.25 acres purchased for $10,500. The church grew and erected a new $200,000 sanctuary with a 72-foot-high steeple and nine classrooms. The Rev. Luther A. Plankenhorn stands outside prior to the new sanctuary's first service in 1962. (Reg McGovern.)

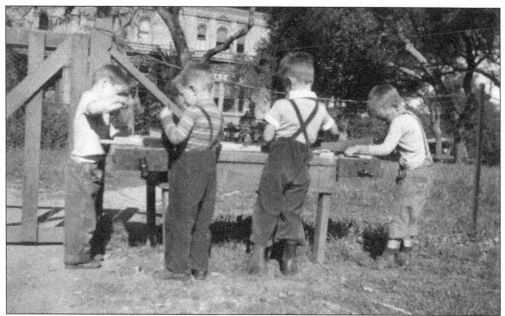

Peninsula School, which opened in 1925, is a progressive school created by an ambitious group of parents, many of whom were associated with Stanford University, interested in moving education from the test-heavy methods of the time. Versed in the progressive movement and led by the noted educator Josephine Duveneck, these parents succeeded in launching the school, which has retained its original focus on child-centered learning. Set in the beautiful and historic Coleman mansion, the Peninsula School's emphasis includes experiential learning and a connection to the great outdoors, illustrated by the photographs taken in the 1940s of boys at the workbench and nursery school children playing on the wooded grounds outside the mansion. (Both, Peninsula School.)

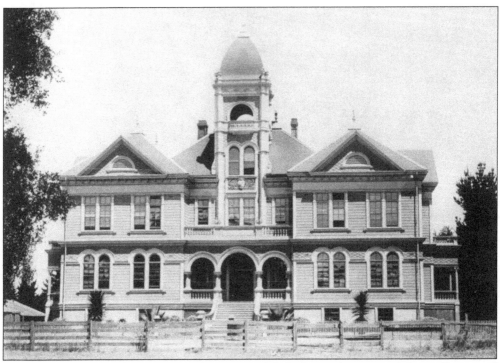

The first public schoolhouse was at the corner of Oak Grove Avenue and Crane Street and opened in 1875. In 1893, a two-story grammar school with a bell tower, pictured here, opened on El Camino Real just south of Glenwood Avenue, only to burn down in 1912. The replacement that went up on the same site became Central School. It was built in 1914 and educated generations of children who would grow up and take their place in the world. The boy in this class portrait from about 1902 whose arm is on the railing at left is a notable example—Alexander Beltramo, one of the five children of Giovanni Beltramo, the founder of the city's celebrated wine business. Central School was demolished in 1963, and Shepard Cadillac occupied the location until it too was razed. (Above, MPHA; below, Beltramo's.)

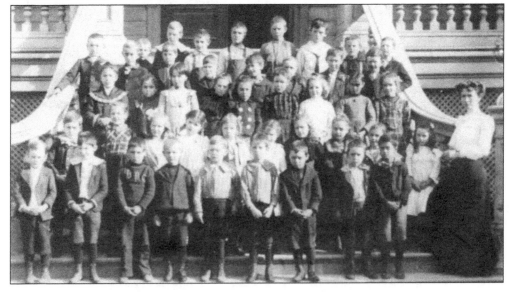

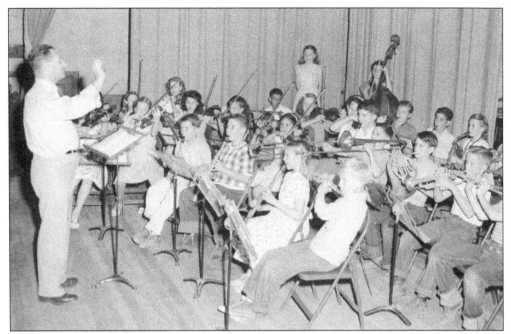

The 35-piece Central School orchestra of Menlo Park, shown here in 1947, performed under the direction of Max Gelber. The youth orchestra was, at that time, one of only a few for grammar school–aged children in San Mateo County. Gelber pioneered instrumental music instruction in Menlo Park, San Carlos, Ravenswood, Belmont, and Redwood City schools and taught at Sequoia High School for 37 years. (Reg McGovern.)

First incorporated in 1961, Trinity Parish School was founded mainly as a coeducational elementary school for parishioners' children. In 1978, a group from the school separated from the church and reincorporated as the Phillips Brooks School. For this photograph of the 1984 graduating class, the students wore formal attire. The school is currently located on Avy Avenue and houses preschool to grade five. (Phillips Brooks School.)

With a doubling of attendance in Menlo Park schools from 1945 to 1949, the need for new and expanded schools was clear. Construction was underway in January 1949 for Encinal School, at Middlefield Road and Encinal Avenue in the Menlo Park School District. School district superintendent Melville Homfeld predicted that without better funding, classes would average 40 to 50 students and all frills would be eliminated. By a vote of more than four to one, in 1952, voters passed a $585,000 school bond with money to add six classrooms and a music room at Encinal, seven classrooms at Hillview, and 10 at Oak Knoll schools. Similarly, just two years after this 1949 classroom photograph at Belle Haven School, the new Ravenswood Elementary District School was confronting double sessions. (Both, Reg McGovern.)

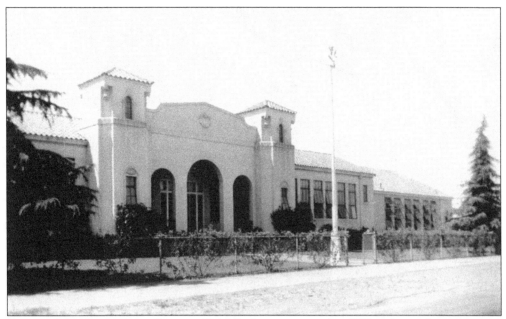

Fremont School, at Fremont Street and Middle Avenue, opened in 1927 and ceased operating as a school in 1971. It had primarily served Allied Arts–area families. In 1977, the city began a 20-year lease-purchase for the site from the Menlo Park School District. After assuming full ownership, the city razed Fremont School in 2000. An expanded Rosener House and Jack W. Lyle Park were created on the old school playground. (MPHA.)

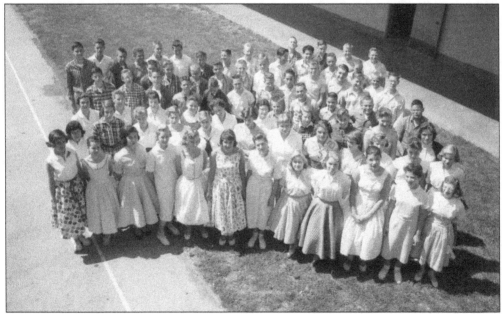

Hillview was one of the schools constructed in response to the baby boom, which challenged districts everywhere. Opened in 1949 as an elementary school, Hillview was repeatedly enlarged and converted to a middle school, preparing students like these in 1958 to advance to the next educational level. In 2012, Hillview emerged from a $51.6-million renovation a middle school transformed for a new generation of students. (Reg McGovern.)

Menlo-Atherton High School, known as M-A, opened its doors to students on September 24, 1951. The school, shown above the following July, was built at a cost of $1.5 million on a 40.9-acre parcel on Middlefield Road that was purchased for $141,105 from the descendants of pioneer banker Joseph A. Donohue. Before M-A opened, Sequoia High School in Redwood City was the only district high school from Belmont south to Menlo Park and East Palo Alto, and Menlo Park was sending 650 students to Sequoia. Advocates, including Mayor Charles Burgess and the chamber of commerce, said that was more than enough to justify their own school. M-A was designed by Arthur D. Janssen of Atherton and constructed by Peter Sorensen. Scovel S. Mayo was the first principal. The photograph below is of the track, which was under construction in March 1953. (Both, Reg McGovern.)

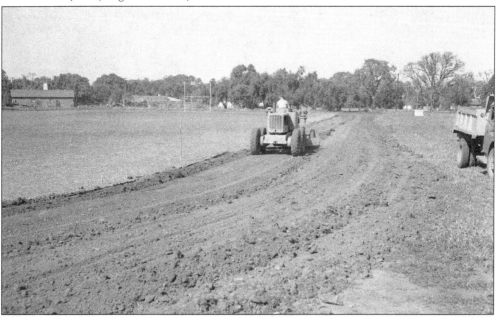

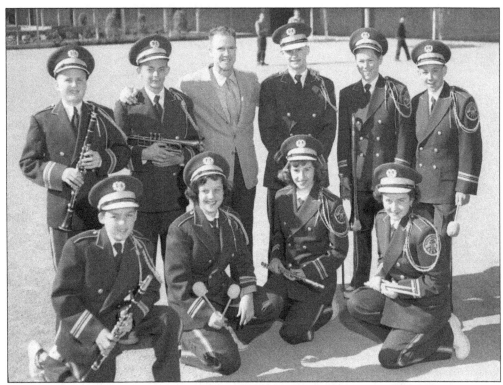

These Menlo-Atherton High School band members showed off new double-breasted uniforms, which arrived just in time for the winter concert in February 1953. The school district spent $2,700 for 60 uniforms. Pictured wearing the maroon, gold-trimmed uniforms are, from left to right, (first row) Charles Strawther, Louise Smith, Margaret Roehr, and Pat Reynolds; (second row) Doyle Barnes, Alvin Earsley, instructor Edward Brown, Bob McAllister, Dick Neklason, and Gerald Mohn. (Reg McGovern.)

M-A is well situated on the San Francisco Peninsula to take advantage of outside resources and expertise, and this 1959 science fair is an early example. Doctors, scientists, professors, and industrial leaders from Ampex Corporation, Stanford University, and the Stanford Research Institute served as judges of the 250-plus scientific displays that were entered. Shows of Bell Telephone movies and a demonstration of stereophonic sound were also featured. (Reg McGovern.)

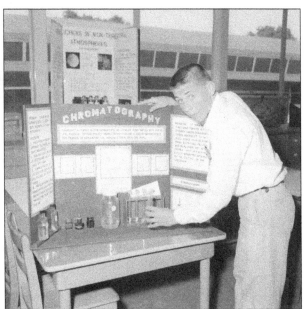

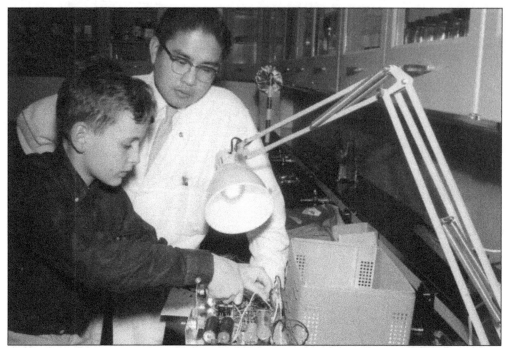

M-A has attracted many top administrators and teachers who have trained and motivated students to excel in high school and beyond. Science teacher Harry K. Wong, pictured here in 1963, taught there for 17 years. After leaving M-A, Wong opened a publishing company, has lectured all over the world on effective teaching methods, and is the author of more than 30 publications, including a best-selling book for teachers. (Reg McGovern.)

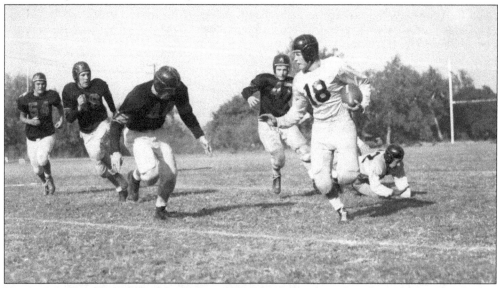

Menlo-Atherton High School had been open just a year when this photograph was taken in October 1952 at the first game for the varsity team, coached by Don Dorfmeier and Howard Costello. Bear halfback Dick Jorgenson (18) is shown here attempting to outmaneuver the Los Gatos High School Wildcat opponents, but despite the mighty effort, the Bears were trounced 19-0. (Reg McGovern.)

In 1960, Ravenswood High School's Trojans were the new kids on the block, and the M-A Bears rolled up a 12-0 victory at Terremere Field. Despite the margin of victory, the Trojans came perilously close to scoring an upset. It made for an exciting night of high school football, though the Bears, coached by Art Boettcher, probably had enough excitement to last awhile. (Reg McGovern.)

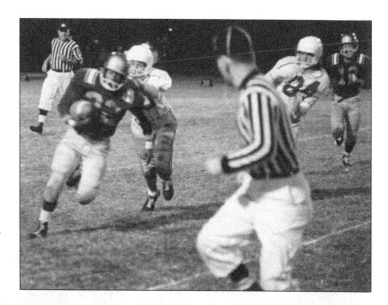

Menlo-Atherton cheerleaders are pictured here in January 1954 urging the Bear basketball team on to victory over Palo Alto High School. Gail (McAlpine) Ross said she and her identical twin sister, Heather, were on the squad that year. According to Ross, they moved to Menlo Park in their junior year and found the new school to be quite open and welcoming to newcomers. (Reg McGovern.)

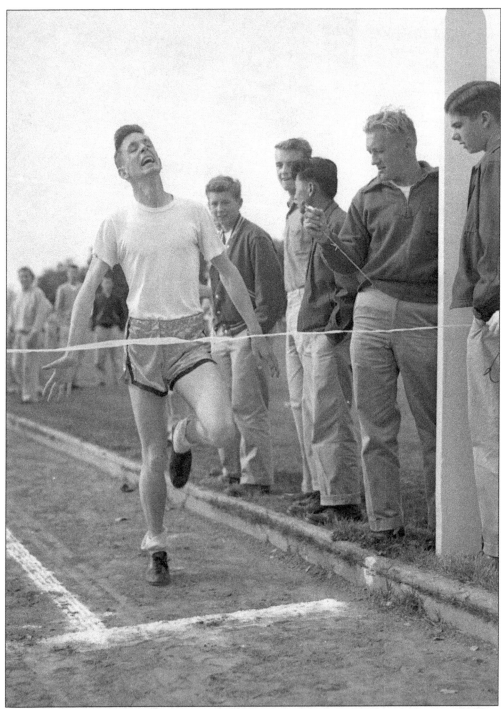

Competing in the early years of the school, sophomore distance runner Ken McKenna turned on the power heading for the tape during this 1953 track meet, winning the 660 in a time of 1:29.8, according to the *Redwood City Tribune*. M-A produced a number of stellar athletes, including Jim Cheatham (track), San Francisco 49er Dave Olerich, and Bob Melvin, who managed the San Francisco Giants and the Arizona Diamondbacks. (Reg McGovern.)

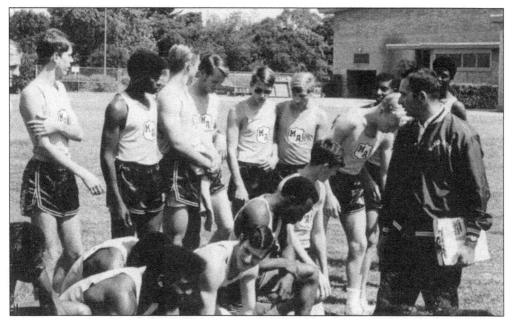

Plato Yanicks coached at M-A from 1965 to 1994, starting the cross-country program during his first year there. Yanicks initiated weight training for cross-country and track teams, as well as physical education classes. One of the most successful coaches in M-A history, his boys' varsity track teams from 1975 to 1986 went 125-11, and from 1982 to 1986, his girls' varsity track teams went 51-2. (Plato Yanicks.)

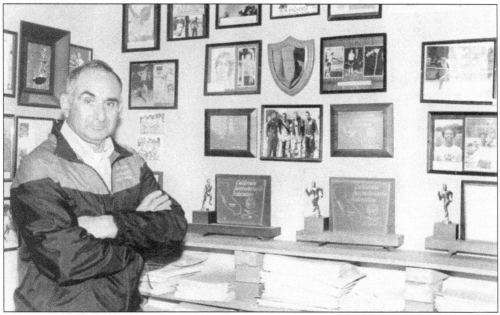

Plato Yanicks had the idea and pushed for the creation of the California State Cross-Country Championship, and the first meet was held in 1987. The walls of his old office in the gymnasium testified to the success of athletes he coached, including 105 individual league champions, 14 individual CCS champions, and several All-Americans. Yanicks was inducted into the Menlo-Atherton Hall of Fame in 2014. (Plato Yanicks.)

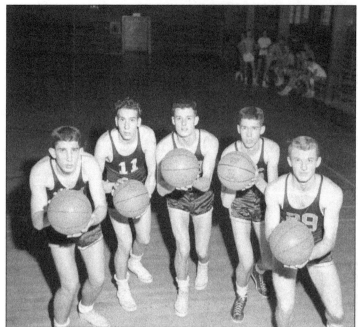

Members of the Menlo-Atherton basketball team were front and center for this photograph taken in January 1953 on the eve of a much-anticipated contest with Sequoia High School. Pictured here from left to right are Bob Elizondo, Pete Ciardella, Dick Forman, Bill Wilkins, and Stan Jacobs. (Reg McGovern.)

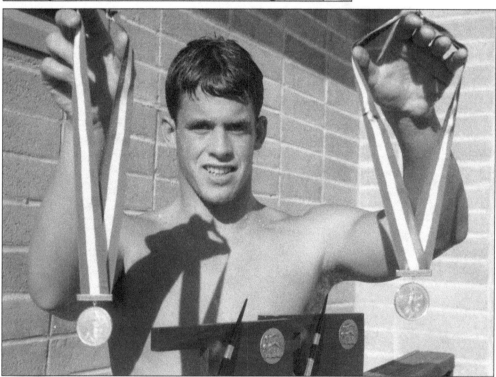

Dick Roth, of M-A's class of 1965, took home a gold medal in the 1964 Olympics in Tokyo. The 17-year-old swimming star was suffering from an acute appendicitis attack but was determined to compete. He did and set a world record (4:45.4) in the 400-meter individual medley. Other M-A Olympic medalists include Anne Warner Cribbs, Greg Buckingham (who broke Roth's record in 1968), and Chris Dorst. (Reg McGovern.)

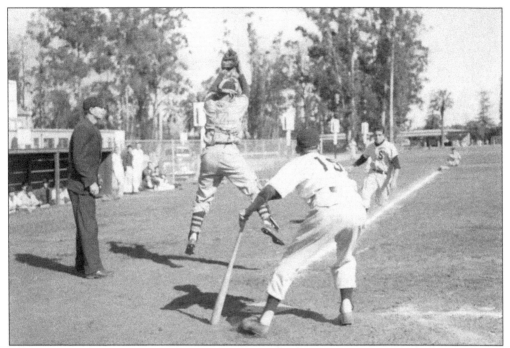

Gary Geagan, Sequoia High School's sophomore shortstop, charges in for the final run in a 10-1 win over Menlo-Atherton in this April 1955 game. Bear catcher Leon Finegold (14) made a high throw but was unable to keep Geagan from scoring in this lopsided Southern Peninsula Athletic League defeat at the hands of the Redwood City rivals. (Reg McGovern.)

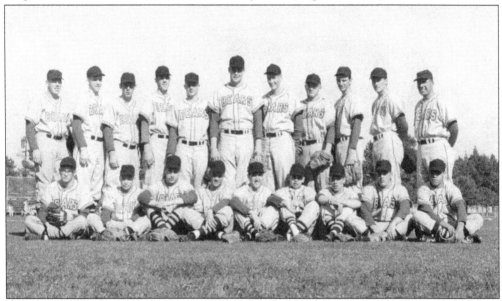

Coach Frank Bettencourt, (second row, right, on end) was an iconic and well-loved figure during his 41-year career at Menlo-Atherton High School. Initially hired in 1953 to coach freshman and sophomore baseball, he went on to coach varsity teams until his retirement in 1994. His son Mark Bettencourt said his father tried to instill in his players good sportsmanship and taught them to accept winning or losing with modesty. (Bettencourt family.)

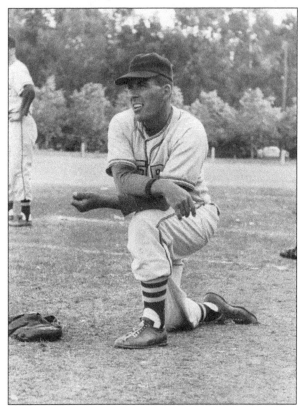

This photograph was taken in 1957 during Frank Bettencourt's first year as varsity coach. During his career at M-A, 14 players signed professional baseball contracts. In 1994, Bettencourt became the first coach selected for the Menlo-Atherton Hall of Fame. He died in 1999, and in 2006, the baseball diamond at the school, which had been reconstructed, was christened Frank Bettencourt Field in his honor. (Bettencourt family.)

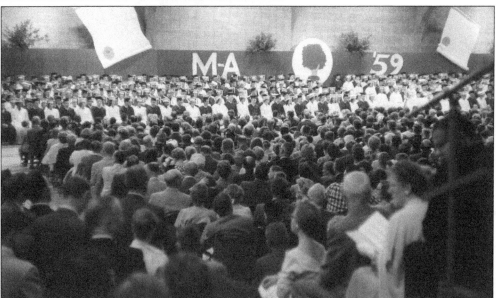

A colorful and solemn ceremony was held in the gymnasium on June 12, 1959, as 454 members of Menlo-Atherton's graduating class received their diplomas before a crowd of about 2,000 assembled family and friends. The M-A band played *Tannhäuser*, and principal Nicholas Nugent presented the class to the superintendent. Senior class president Roger Burpee introduced the speakers, salutatorian Barbara Buckholtz and valedictorian Paul Welden. (Reg McGovern.)

Three

GOVERNMENT, BUSINESS, AND INDUSTRY

The City of Menlo Park's government center sits in the geographic heart of town, which is flanked on the east and west by important scientific laboratories. The city center sits on land that was once part of the Hopkins estate, later Dibble General Hospital.

Both world wars impacted the area as well. During World War I, the area west of El Camino Real to Alameda de las Pulgas between the San Francisquito Creek and Valparaiso Avenue served as the cantonment area for Camp Fremont's more than 40,000 soldiers. World War II saw the construction of additional railroad spurs to serve the Army's Dibble General Hospital.

The Menlo Park Police Department has permanently retired badge No. 3 in honor of officer John W. Lyle, who was the only policeman from the department to give his life in the line of duty. Lyle, a husband and father of four and an eight-year veteran of the Menlo Park Police force, was 29 years old on September 22, 1960, when he was investigating a stolen car with the driver inside. Lyle was killed in the encounter, and the perpetrator was arrested, convicted, and executed for the crime. The park at Middle and Fremont Streets was named in his honor.

The Menlo Park Fire Protection District has evolved from a group of volunteers pulling a horse-drawn water pump to one the world's most respected urban search-and-rescue organizations. The Menlo Park Fire Search and Rescue Team, known as California Task Force 3, has been called upon to be the first responders to such tragedies as the Murrah Federal Building bombing in Oklahoma City on April 19, 1995, and the World Trade Center attack on September 11, 2001.

The city enjoys a number of parks within its boundaries, from Flood Park, built along Bay Road on property formerly part of the Flood mansion, to Bedwell Bayfront Park, east of Highway 101, which was once the site of the city's landfill.

Menlo Park is home to a number of government and private-sector businesses that are large employers in the area, ranging from the SLAC National Accelerator Laboratory to SRI International, *Sunset* magazine (owned by Time, Inc.), and many others.

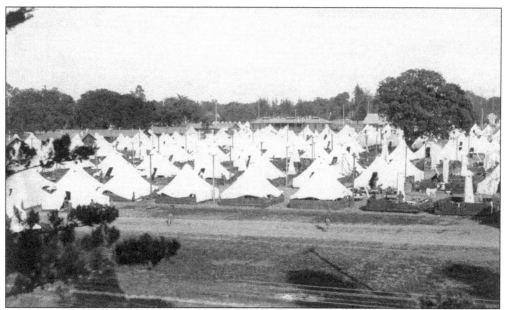

When the United States became involved in World War I, the US Army set up 16 mobilization and training camps to integrate National Guard units into the Regular Army. Camp Fremont was established on July 18, 1917, on 7,203 acres of land that stretched west from El Camino Real into the foothills behind Menlo Park, Palo Alto, and Stanford University. More than 27,000 soldiers lived in 6,000 wood-floor tents while training in the area. (MPHA.)

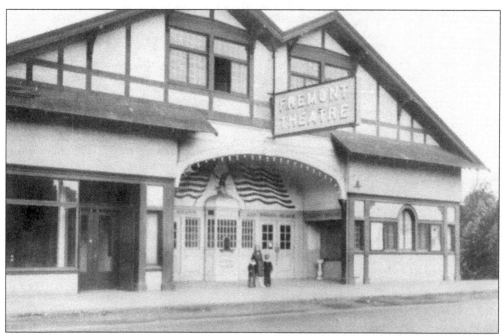

The 1,000-seat Camp Fremont Theater was located on the east side of El Camino Real between Santa Cruz and Ravenswood Avenues. Here soldiers and townsfolk could see first-run movies and five vaudeville acts each night. The soldiers had a tendency to get a little rowdy during the vaudeville performances, heckling the actors if their performance was not up to par. (MPHA.)

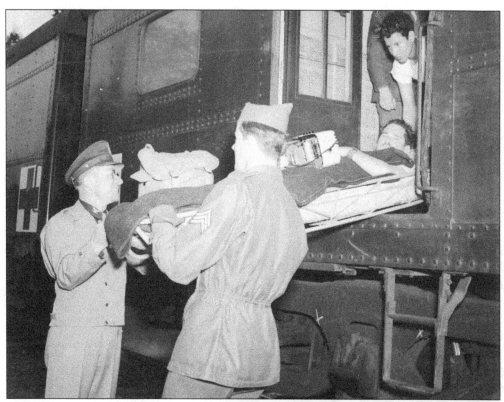

Menlo Park welcomed wounded warriors returning from the Pacific theater during World War II. Built in just four months, Dibble General Hospital occupied the former Hopkins estate between El Camino Real and Middlefield Road and specialized in reconstructive and eye surgery and orthopedics. Above, Pvt. James Dobson, shown in the stretcher, was one of the 124 patients who came from a hospital in Southern California. (Reg McGovern.)

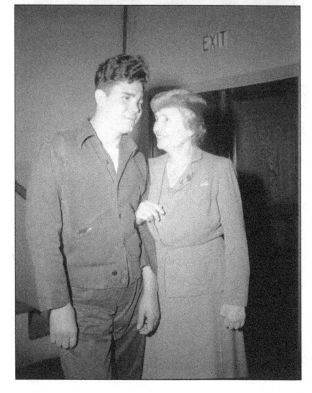

Many entertainers visited recuperating patients at Dibble Hospital, but it was hard to overstate the connection made by Helen Keller, right, when she visited on April 22, 1946. She offered a unique encouragement when she stopped to talk with soldiers like PFC Harry Carmack, who lost his sight during the war. (Reg McGovern.)

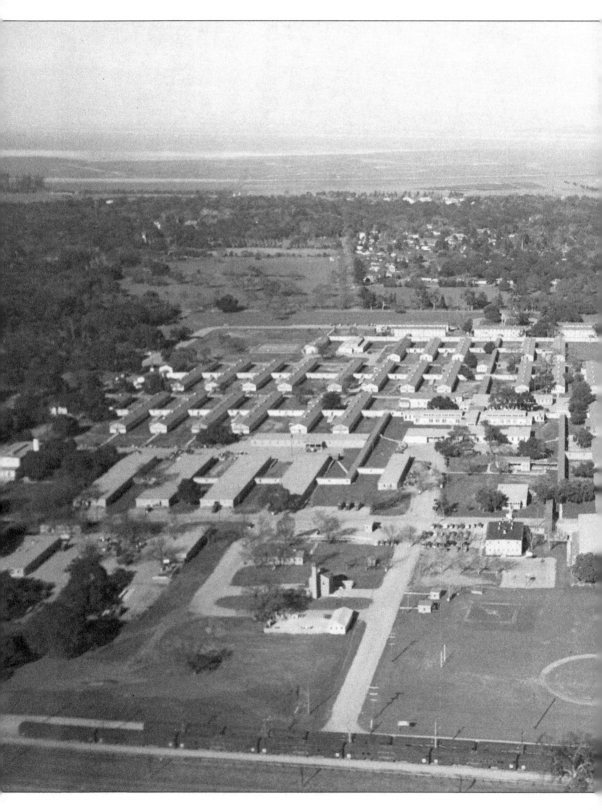

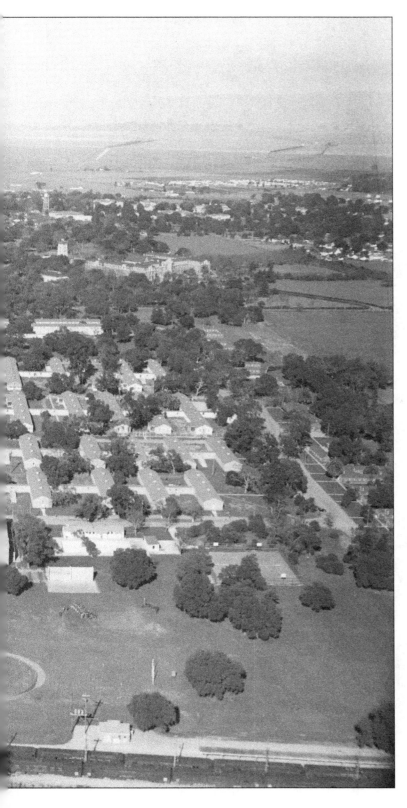

This aerial view of
Dibble General Hospital,
taken in February 1946,
shows how this Army
installation has been
transformed from the
grounds of an estate
to a facility of more
than 94 buildings, the
majority of which were
connected by enclosed
walkways. Middlefield
Road and St. Patrick's
Seminary can be seen
in the right center of
the photograph, and the
Veterans Administration
hospital and the
Dumbarton Bridges
are in the upper right.
(Reg McGovern.)

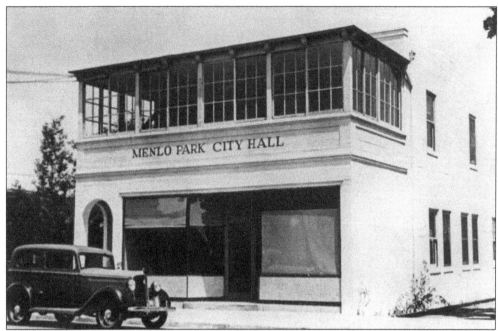

Menlo Park's first city hall, at 1036 Doyle Street, is pictured here in 1935. The building was situated between Santa Cruz and Menlo Avenues, and its second floor was home to the city's library. In 1939, city hall moved to 1090 El Camino Real, on the southeast corner of Santa Cruz Avenue. Today the site of the original city hall is a parking lot for Bank of America. (MPHA.)

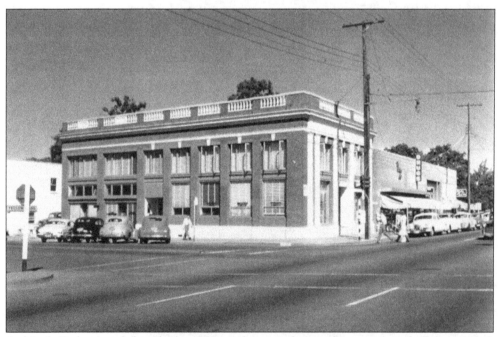

As Menlo Park expanded in the late 1930s, it became obvious that a new city hall was needed. In 1939, the city's offices moved to 1090 El Camino Real, in the former Palo Alto National Bank building. The building is pictured here in 1951. (MPHA/EHC.)

When the Army closed Dibble General Hospital in 1946, the land was turned over to the Federal Public Housing Authority. Two years later, the City of Menlo Park was in need of new administrative space and acquired 26 acres of former Dibble General Hospital land and buildings at a cost of $4,000 per acre. City staff moved into the former military buildings later in 1948. This parcel later became the present-day civic center, on Laurel Street, home to a myriad of city offices, the library, and police. (MPHA/EHC.)

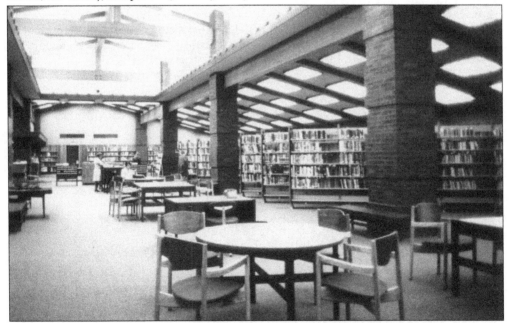

The Menlo Park library has a long and transient history that started with a 50-book collection at Central School in 1916. The library moved to the Menlo Park Hotel in 1926 and to city jail in 1930, moving again in 1939 to the building that now houses the British Bankers Club on El Camino Real and a bungalow on Menlo Avenue in 1948. The final move came in 1957, when a permanent home was designed specifically for the library and incorporated into the civic center at 800 Alma Street. (MPHA.)

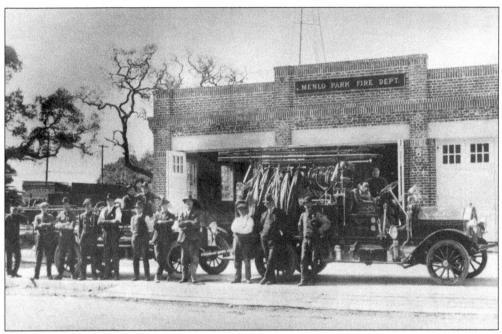

On September 16, 1915, the Menlo Park Fire Protection District was formed, 12 years before the city incorporated. The city's first firehouse was located at 1077 Merrill Street, facing the railroad tracks, above. The three-bay brick building served as the fire district's headquarters until 1955, when a new station was constructed on the corner of Middlefield Road and Santa Monica Avenue. Menlo Park Fire District's Engine No. 2 was housed near Bayshore Boulevard, as seen below. At right is Chief Thomas F. Cuff, former Berkeley Fire Department captain, seen with Engine No. 2 and a fire car. Chief Cuff led the department until 1955. (Both, MPHA.)

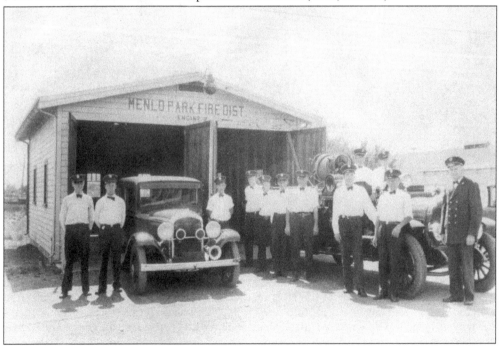

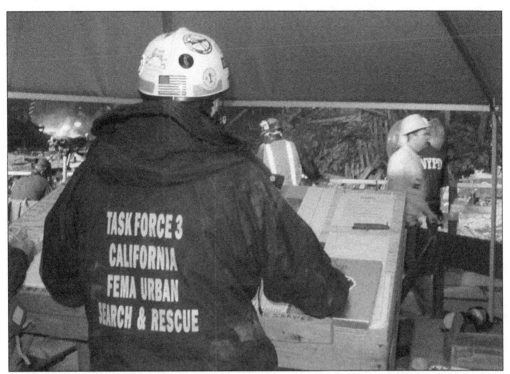

In the immediate aftermath of the September 11, 2001, terrorist attacks on the World Trade Center, 67 members of the California Task Force 3 (CATF3) National Urban Search and Rescue Team volunteered to work at Ground Zero of the site; 20 of the CATF3 team members were staff from the Menlo Park Fire Protection District. CATF3 specializes in extracting victims trapped in building collapses during earthquakes and other natural disasters, as well as terrorist attacks. Division chief Frank Fraone, seen below among the World Trade Center rubble pile, was on site for 16 days, serving as one of the operation's section chiefs on the incident management team. Fraone managed half of the nighttime operations with all rescue teams on site. (Both, Frank Fraone.)

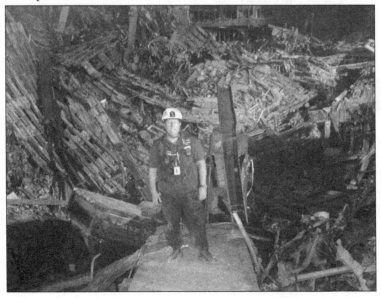

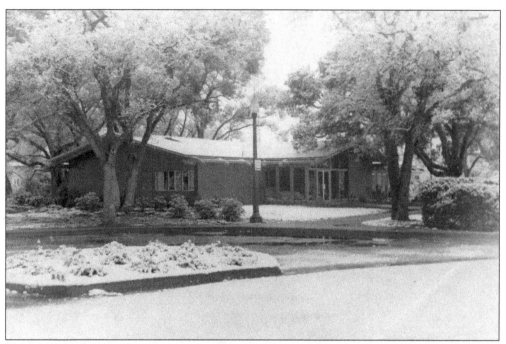

The Menlo Park Police Department was located in this building at 785 Laurel Street in February 1962 when snow fell and stuck to the ground. The police department moved to 701 Laurel Street, and the building became the Menlo Children's Center in May 2006. (Rhonda Cumming Collection.)

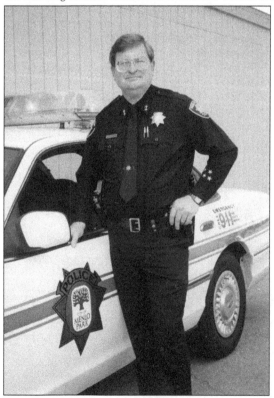

Menlo Park police chief Bruce Cumming was named to the position in June 1988. As Menlo Park's chief, Cumming was instrumental in opening a station in the Belle Haven neighborhood and teaming with area departments and the San Mateo County Sheriff's Department to reduce crime in East Palo Alto. After serving as the chief for more than 10 years, Cumming retired on March 8, 1999. (Rhonda Cumming Collection.)

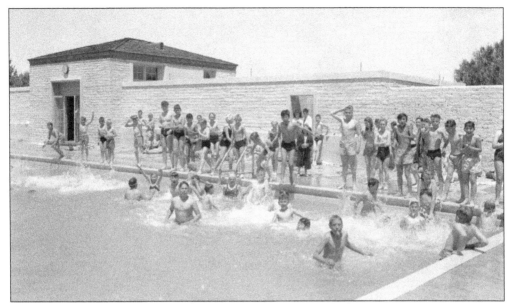

Shown cooling off on a hot day in 1948, Menlo Park children enjoy having San Mateo County's Flood Park right in the neighborhood. Located on Bay Road, the land had been part of the 600-acre tract where James Clair Flood built his residence, Linden Towers. In the early 1930s, the county purchased 21 acres of the Flood estate, which was being sold off for subdivisions. Some facilities, including the pool, were constructed in 1936 as part of the Works Progress Administration to provide jobs during the Great Depression. (Reg McGovern.)

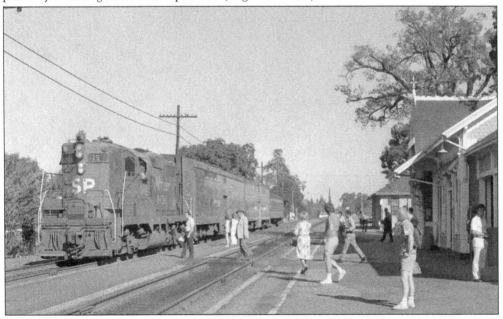

Passengers gather as Southern Pacific train No. 15 pulls up in this June 1976 photograph. Southern Pacific had closed the ticket office in 1959 and leased the depot to the city for use by community organizations. In 1987, approximately $800,000 was spent to develop a modern transportation center by rehabilitating the depot and baggage house and adding a clock tower and bicycle corral. (John Harder.)

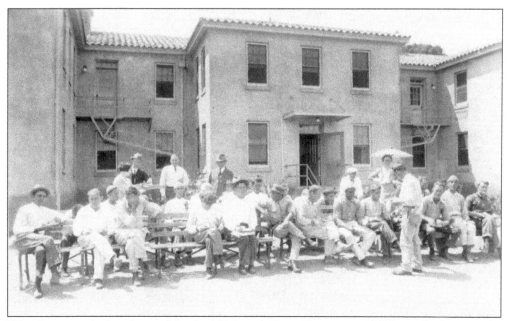

What began as the base hospital for the US Army's Camp Fremont in 1917 has today become the Menlo Park Division of the Veterans Administration Palo Alto Health Care System, located at 795 Willow Road. After World War I, the facility was used for the recuperation of tubercular patients, above, and later served as a psychiatric facility. Here veterans are seen undergoing corrective hydrotherapy for a variety of mental health conditions. Today the Menlo Park Division offers a variety of physical and mental health and vocational services to veterans. (Both, MPHA.)

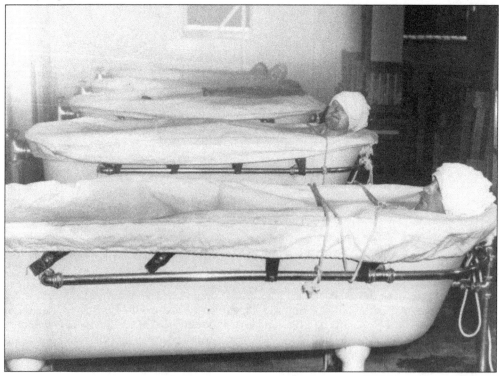

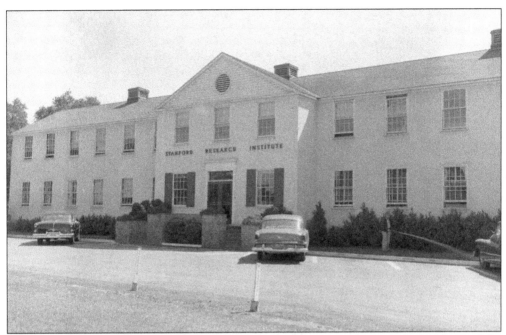

The Stanford Research Institute (SRI International) took up residence in the buildings of the former Dibble General Hospital in 1947, shortly after the laboratory and think tank was founded. As an independent research institute, SRI International provides product development, testing, and consultation services to a wide range of industries. The institute employs more than 2,500 people and through the years has been awarded more than 1,000 patents. Below is a diagram representing some of SRI International's advanced work with various types of radio and radar waves from the mid-1960s. (Above, Reg McGovern Collection; below, Rick Turner Collection.)

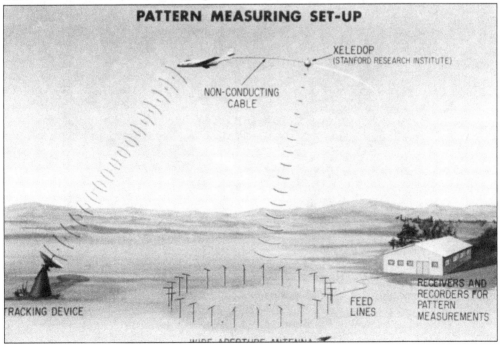

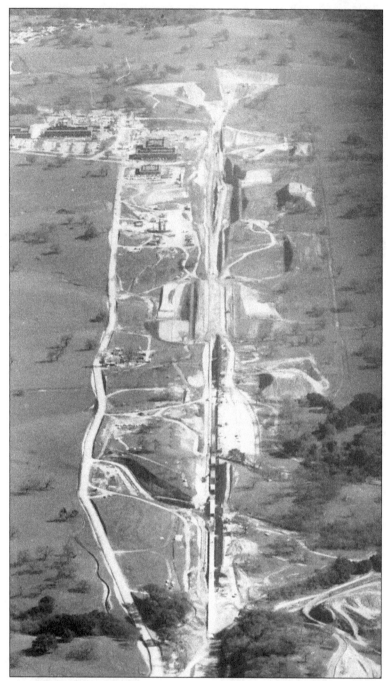

Stanford Linear Accelerator Center (SLAC) sits on 426 acres of Stanford-owned land on Sand Hill Road. Construction began in 1962 on the two-mile-long main accelerator, still the longest linear accelerator in the world, and operations began in 1966. Note that Interstate 280 has not yet been built over the accelerator in this photograph. To date, six scientists have received the Nobel Prize for work performed at SLAC, and thousands of scientific papers have been published. In 2008, the US Department of Energy, which has oversight of the facility, changed the name to SLAC National Accelerator Laboratory. (Reg McGovern.)

The US Geological Survey moved into a 16-acre campus of former Dibble General Hospital buildings in 1954. Six of the temporary tar paper hospital buildings survived into the mid-1990s before the last one was torn down. Today, the USGS campus on Middlefield Road is state-of-the-art and home to the California Volcano Observatory, the Pacific Coastal and Marine Science Center, and the Earthquake Science Center, to name a few. (USGS.)

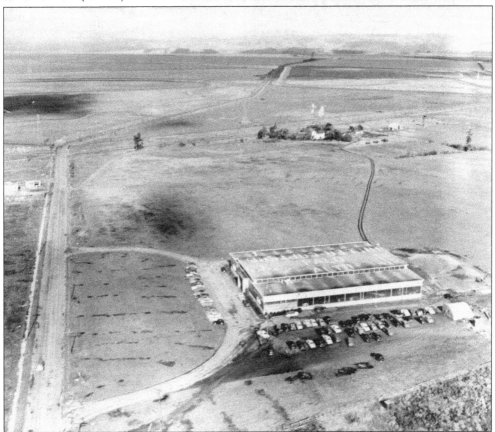

Vertical flight visionary Stanley Hiller Jr. (1924–2006) designed the first coaxial helicopter and formed United Helicopters with industrialist Henry J. Kaiser in 1945. In 1948, the company was renamed Hiller Helicopters and built versions of the UH-12 light helicopter for civilian and military uses. The factory, pictured here around 1950, was located on Willow Road between what is now Highway 101 and Bayfront Expressway. In the distance at the top of the photograph, the Dumbarton Bridge is visible. (Hiller Aviation Museum.)

Sunset began in 1898 as a promotional magazine for the Southern Pacific Railroad and has evolved as the times have changed. The Lane Publishing Company purchased the floundering magazine in 1929 and slowly rebuilt its image to "Western Lifestyle at Its Best." After five decades in several locations throughout downtown San Francisco, *Sunset* moved its headquarters to 80 Willow Road, Menlo Park, in 1951. The 30,000-square-foot, adobe-ranch-style building was built on land once part of the Hopkins estate. The interior was state-of-the-art and included test kitchens, as shown below in 1953, that were used to refine the thousands of recipes developed for the magazine each year. Melvin B. "Mel" Lane (left), one of the cofounders of Lane Publishing, not only helped guide *Sunset* magazine into the highly regarded premier how-to magazine it is today but was also a defender of the environment. He served on several commissions to safeguard California's coast, having made a large impact on preserving California's natural beauty. (Both, Reg McGovern.)

Responding to the do-it-yourself penchant of postwar Americans, Dr. Hans Goldschmidt developed the Shopsmith, a combination saw, lathe, and drill press. Here Barbara Davis shows the Shopsmith at the Menlo Park location of Magna Engineering Corp. on January 22, 1953. The company had been in business since 1948 and generated more than $20 million in sales before moving to its location on Linfield Drive in 1951. (Reg McGovern.)

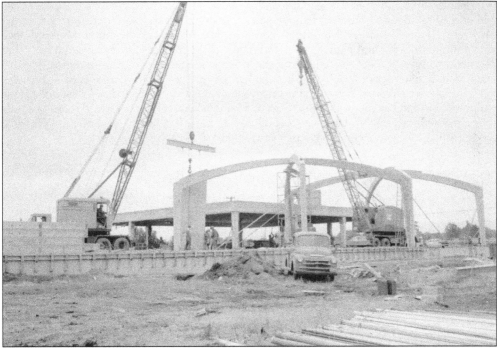

David D. Bohannon, founder of Bohannon Companies, began his career in the 1920s and was responsible for the construction of thousands of postwar-era homes throughout the Bay Area, including the 540-acre Belle Haven subdivision in Menlo Park. In the early 1950s, Bohannon Companies branched out into commercial development and began construction of the 200-acre Bohannon Industrial Park. This June 20, 1958, photograph shows the tilt-up walls being assembled on one of the many buildings within the park. (Reg McGovern.)

A former landfill site, pictured here in 1962, got a new lease on life in the 1980s after it was closed and capped off. Bedwell Bayfront Park, which was named in honor of longtime city manager Michael A. Bedwell, consists of 160 acres of open space and wildlife habitat that was refurbished with thousands of natural plants, trees, and shrubs. The area has many trails and hills that provide expansive views of the refuge and the bay, and the park is popular for hiking, jogging, bird watching, nature photography, and many other activities. Bedwell Bayfront Park is also home to the unique art sculpture known as the *Great Spirit Path*, which is considered the largest stone sculpture of its kind in the world. It consists of 53 individual sculptures with 505 tons of stones over a three-quarter-mile distance corresponding to a poem written by local Menlo Park artist Susan Dunlap. (Above, Reg McGovern; below, MPHA/PTT/Bob Andres.)

Four

ROADS, RAILS, AND BRIDGES

When the first train of the San Francisco & San Jose Railroad arrived in 1863, Menlo Park's fortunes were hitched to a transportation mode that brought new residents—from wealthy businessmen who built huge estates in the area to laborers, merchants, hoteliers, shopkeepers, and many others—all of whom put down roots. By the late 1880s, Menlo Park was being promoted by the original railroad's successor as one of the resorts on the Southern Pacific's "Great Pleasure Route of the Pacific Coast." Travel writers rhapsodized about the scenic ride along the peninsula to Monterey.

Blessed with a temperate climate, Menlo Park's flat terrain proved fertile ground for growers, including Timothy Hopkins, who established the Sunset Seed and Plant Company on the grounds of his estate. Lynch Nursery, begun in the late 1880s by Hopkins's former gardener, was able to ship thousands of carnations and chrysanthemums from its extensive greenhouses and open-air gardens daily over the Dumbarton Rail Bridge after it opened in 1910. The railroad connected Menlo Park to faraway markets and supported the military bases in the area. Later used primarily for freight, the railroad bridge is the oldest spanning the bay; today it is no longer used or useable. Another Dumbarton Bridge—for vehicles—opened in 1927 and lasted until it was replaced in 1982.

In the early days, El Camino Real, commonly known as "the Highway," connected towns down the peninsula. Between Menlo Park and Palo Alto, a bridge along El Camino Real crossed over San Francisquito Creek. Initially, the center of commerce and activity in Menlo Park was near the railroad depot, but after World War II, development westward along Santa Cruz Avenue intensified. As growth later continued toward Alameda de las Pulgas and beyond, that arterial and Sand Hill Road were widened and improved.

For travel beyond the city limits, the Bayshore Freeway was completed to Menlo Park in 1957; two decades later, Interstate 280 opened. Today a public transportation network that includes buses, Caltrain, and shuttles is centered on the place where it all started—the landmark railroad depot. Menlo Park's transportation story has come back full-circle.

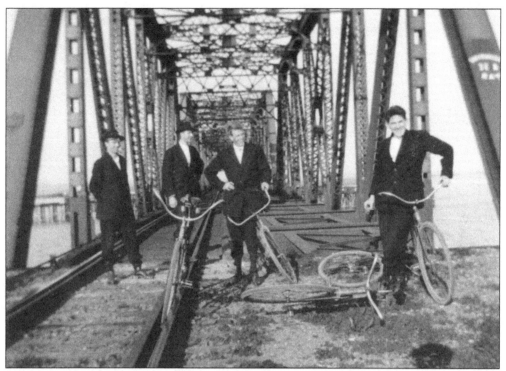

The 1910 opening of a railroad connection between Menlo Park and Newark—and the rest of the country—was exciting news, perhaps motivating these St. Patrick's Seminary students to hazard a hike to check it out. The $3.5-million bridge avoided the need to transport freight across the bay by boat. By 1911, a new townsite at the bridge's western terminus, Ravenswood, was being promoted as the ideal place for factories to locate. (Archives of the Archdiocese of San Francisco.)

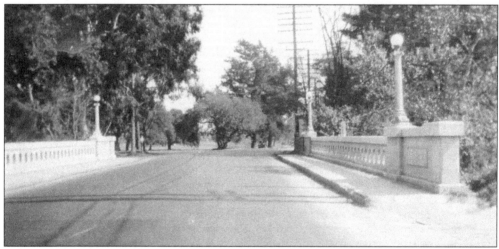

The El Camino Real bridge over San Francisquito Creek (looking to the south into Palo Alto) was constructed in 1913, and the center of the creek below serves as the dividing line between San Mateo and Santa Clara Counties as well as that between Menlo Park and Palo Alto. The bridge spans 62 feet, and it has undergone a series of improvements through the years. The rail on the west side of the bridge dates from the early 1930s. The bridge was widened to four lanes along with El Camino Real in 1937–1939 and expanded to its present eight-lane width in 1955. (MPHA.)

This view looks north on El Camino Real at the corner of Santa Cruz Avenue in late 1938, as the project to widen the main thoroughfare between San Francisco and San Jose reached Menlo Park. Curbs and gutters are drying, and soon paved sidewalks and traffic lanes will follow. (Kathleen Lorist Collection.)

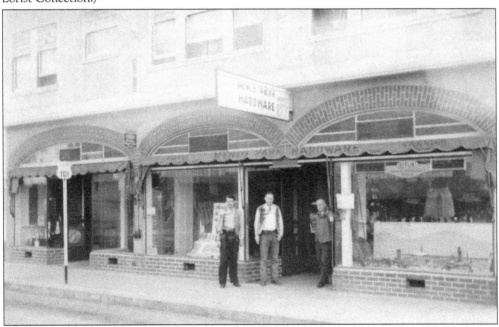

Widening of El Camino Real was finished at the beginning of 1939. Note the road sign proclaiming El Camino Real as US Route 101 in this March 23, 1939, photograph. Bayshore Boulevard was built as Bypass 101 while El Camino Real remained Route 101. In 1964, El Camino Real became California Route 82 and the Bayshore bypass was designated US Route 101. Bernie McLaughlin (left), Dominic Ryan (center), and J. William "John" Ryan stand in the doorway of Menlo Park Hardware, a family business John Ryan started in 1924. (Kathleen Lorist Collection.)

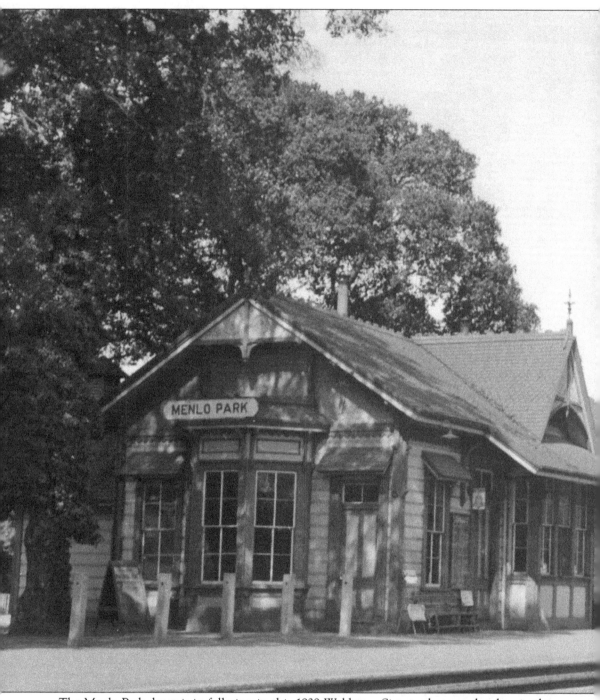

The Menlo Park depot is in full view in this 1939 Waldemar Sievers photograph taken in the morning as Santa Cruz–bound Southern Pacific steam locomotive No. 2381 arrives pulling Train 34. Quite plain originally, the Menlo Park depot received a Victorian gingerbread treatment and sloped wooden awnings over each window and door when the building was remodeled in 1890 in preparation for the opening of Stanford University in 1891. Brackets, fancy moldings, decorative "fish scales," and scallop cresting on the roofline gave the depot a homey look. In 1917, the depot's

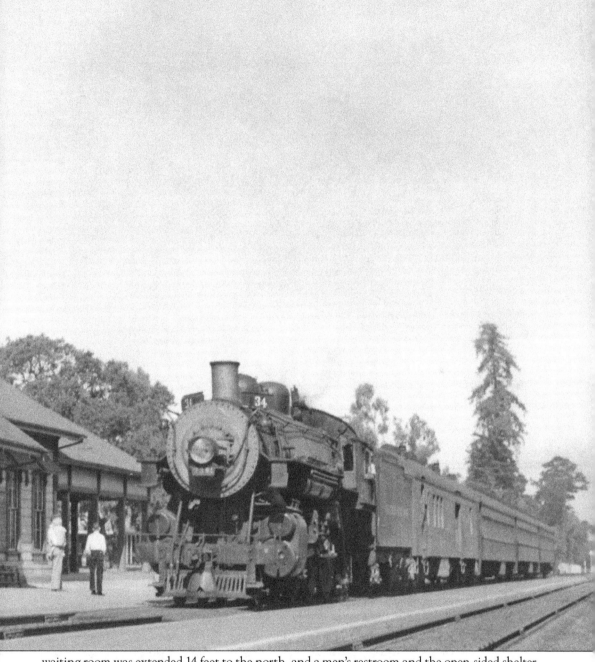

waiting room was extended 14 feet to the north, and a men's restroom and the open-sided shelter were added to accommodate nearly 30,000 troops passing through nearby Army training center Camp Fremont. World War II occasioned yet another remodeling to accommodate increased troop travel. A well-loved landmark, the depot was listed in the National Register of Historic Places in 1974. (John Harder Collection.)

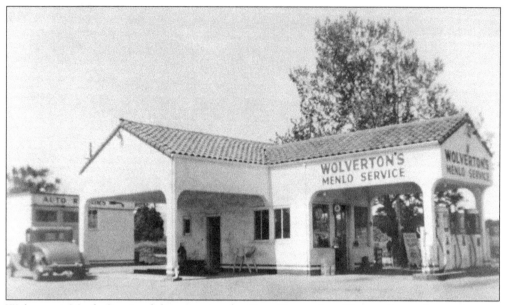

Wolverton's Menlo Service did not survive the Great Depression. The service station and garage began operations after 1926 and was out of business before the start of World War II. (MPHA.)

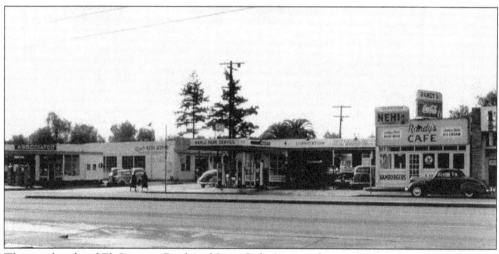

The south side of El Camino Real and Live Oak Avenue featured one of Menlo Park's two Associated Service stations and Menlo Park Service at 901 El Camino Real. Both stations sold gas and did automotive repair work. Today the service stations are gone, replaced by retail stores, including Menlo Flooring and Design. Randy's Café was a diner-style restaurant where patrons could enjoy a good meal and be entertained by the novelty known as television. (MPHA.)

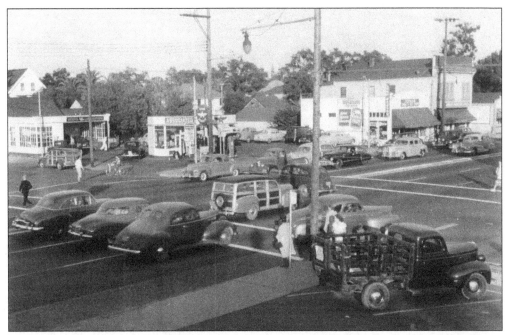

This image illustrates the need for a signal at the corner of El Camino Real and Oak Grove Avenue. One car traveling east appears to be caught between north- and south-bound traffic, and there is a pedestrian in the crosswalk. Associated Service Station No. 522 occupies the southeast corner with Menlo Bike and Key (later Menlo Cyclery) next door and Menlo Grocery farther north. Today, FedEx Office occupies the former Associated Service station location, and presently Feldman's Books is in the Menlo Grocery location. (MPHA.)

Pictured here are, from left to right, Adam Patterson, Charlie Cattaneo, and two other unidentified Associated Service station employees. Known as "Flying A" for the company's winged logo, the stations were rebranded as Phillips 66 stations when that company acquired the Flying A brand in 1966. At one time, all but three of the corners in Menlo Park along El Camino Real had gas stations on them. (MPHA.)

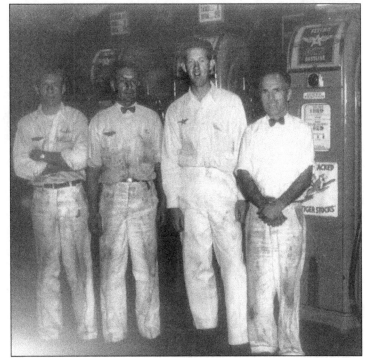

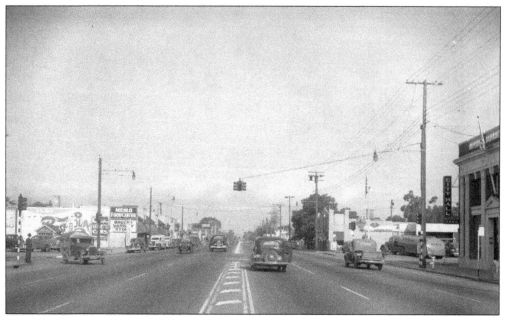

The widened, six-lane El Camino Real at the intersection of Santa Cruz Avenue looking north is pictured here on April 5, 1946. Today, on the north side of the street, the Shell station and Duca and Hanley grocery are gone, replaced by a McDonald's restaurant and a commercial building home to a nail salon, an architect's office, and a ballet studio. The second Menlo Park City Hall was located on the southeast corner of this intersection. (Reg McGovern.)

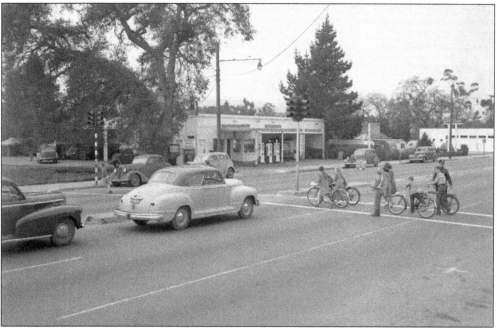

With the now-widened El Camino Real and increased traffic during the immediate postwar years, it became necessary to ensure the safety of children traveling to and from the Central School. In this photograph from March 3, 1947, a student crossing guard and a police officer make sure everyone obeys the traffic laws. (Reg McGovern.)

Sgt. Joe Ferriera is on the lookout for speeders during a 1946 enforcement push on El Camino Real, part of the state highway system. With the business district and a school next to the road, residents and city officials wanted drivers to slow down from 55 miles per hour entering the city limits. After a two-year battle, the state allowed the reduction to 25 miles per hour. Sergeant Ferriera is sitting close to Valparaiso Avenue, up the block from the Park Theater and the 76 service station. (Reg McGovern.)

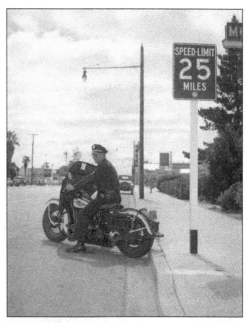

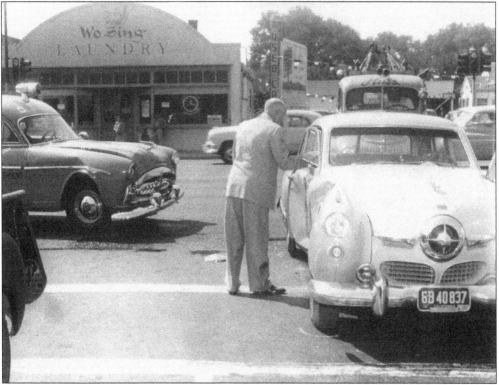

Above is the scene of a midday car accident between a Studebaker and a US Navy Packard ambulance in front of Wo Sing Laundry at 961 El Camino Real. Wo Sing Laundry also had a production plant at 548 Glenwood Avenue, near El Camino Real. The laundry later moved to 570 Derry Lane, behind the Foster's Freeze hamburger stand. Today, 961 El Camino Real is home to Menlo Clock Works. (MPHA.)

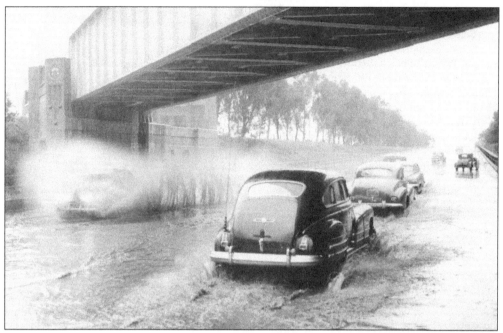

This was the scene at the height of an afternoon rainstorm on October 26, 1950, at the underpass at Bayshore Highway and the railroad bridge. It was flooded with two feet of water, causing some automobiles to stall. The vehicle at the extreme left can be seen splashing water into the air above its roof. It, too, stalled before making it to the top of the grade. (Reg McGovern.)

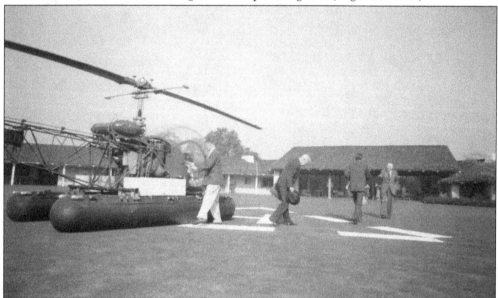

The *Sunset* magazine grounds were the site of a first in commercial aviation in the Bay Area on December 4, 1956. On that date, a new charter helicopter service was introduced by Rick Helicopter, Inc., when the Bell 47 took off from the San Francisco Ferry Building heliport and landed 30 minutes later at *Sunset's* campus with Lane Publishing Company executive vice president Howard Willoughby and J. Russell Holmes, a sales representative for Crown Zellerbach Corporation, on board. (Reg McGovern.)

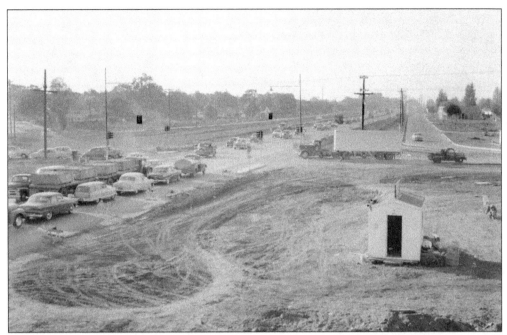

Thick traffic clogs the Bayshore Freeway during the afternoon commute on October 12, 1955. The beginnings of the Willow Road and Bayshore cloverleaf can be seen in the foreground. The work would take another six months to complete. This stretch of roadway eventually became today's Highway 101. (Reg McGovern.)

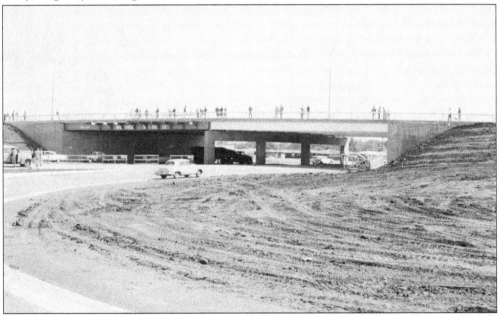

As construction of the Bayshore Freeway advanced down the peninsula, commuters from Menlo Park and nearby communities looked forward to the March 1956 opening of the new Willow cloverleaf. The new cloverleaf facilitated the trip home from San Francisco and also funneled traffic to and from the Dumbarton Bridge. Spectators stand on the overpass watching the first cars enter the roadway on March 15, 1956. (Reg McGovern.)

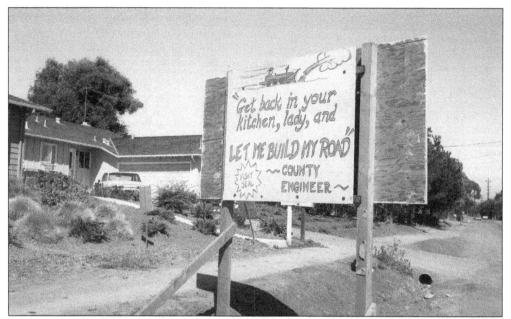

The unincorporated stretch of Alameda de las Pulgas was the scene of a bitter battle in the mid-1960s, when San Mateo County traffic engineers proposed making the road a major arterial from Sand Hill Road to Atherton. The plans for an upgrade with four traffic lanes, sidewalks, curbs, gutters, and a 10-foot divider led to one of the bitterest conservation fights in many years. Note the dirt walking path and drainage ditch in front of this home. (Reg McGovern.)

The historical marker honoring Dennis Martin, who built the first Catholic church in San Mateo County, had to be moved a few hundred yards down Sand Hill Road in 1967 because it was in the path of the Junipero Serra Freeway (Interstate 280). E.H. Bean of Redwood City had the job of moving the stone monument. Today the monument sits near the entrance to 3000 Sand Hill Road. (Reg McGovern.)

Five

DOWNTOWN AND AROUND TOWN

Both world wars transformed Menlo Park; the first inundated a small town with thousands of troops and the second with returning soldiers eager to put down roots and start families. Early on, Menlo Park's core—centered around the railroad station—expanded to El Camino Real. As the postwar population grew and demand for services and commerce with it, stores and other businesses multiplied, extending to Santa Cruz Avenue and side streets downtown.

In 1948, Menlo Park was on the verge of something big. A weeklong centennial festival marked not only the state's birthday but also the opening of a new parking plaza, a medical office building, and the start of construction on a new post office and library. Long-standing businesses like Menlo Hardware were joined in the postwar decade by newcomers that would become mainstays as well, such as Ann's Coffee Shop, Preuss Pharmacy, Menlo Camera, Guy's Plumbing, and the Guild Theater. It is remarkable how long many Menlo Park businesses have been in operation but equally inspiring that many have been continued by the same families for generations. Beltramo's Wine and Spirits and Draegers Markets are obvious examples, but Flegel's Home Furnishings, Menlo Gift Bazaar, and Round Table Pizza are also carrying on through multiple generations.

As the city grew from the 1960s and beyond, vast acreage of the former Sharon estate and other land in both the eastern and western edges of the city were transformed for commercial and residential developments.

Despite the magnitude of changes that stretched Menlo Park in new directions, residents value their community's charm and small-town feel and have always stood behind worthwhile programs. In 1949, volunteers pioneered the new concept of a senior citizens center. They forayed into amateur theatrical productions that led to the creation of the Menlo Players Guild. They even had the vision to see a park in a former landfill site. Though some traditions are gone, as are some of the stores and businesses that residents remember with fondness, Menlo Park—like its signature oak tree—stands rooted in the past, thriving in the present, and growing into the future.

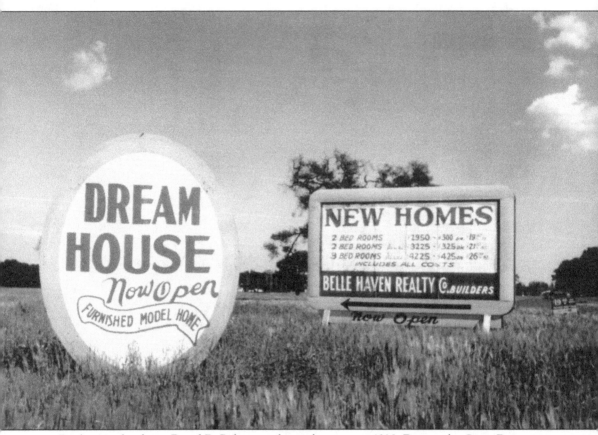

Real estate developer David D. Bohannon began business in 1928. During the Great Depression of the 1930s, Bohannon sold home sites and built more than 1,300 homes in an unincorporated area of San Mateo County known as "Belle Haven City." It only took $300 down with payments of $19.40 per month to buy a two-bedroom home in the Belle Haven section of Menlo Park in the days before World War II. During the war years, Bohannon built homes for war workers in various areas, most notably the San Lorenzo Village in the East Bay. As the war drew to a close, he also planned what would become the Hillsdale Shopping Center in San Mateo. It was completed less than nine years after the end of the conflict and today is the largest shopping center in the county. By the mid-1970s, the Bohannon Organization had developed communities from Sacramento to San Jose and west to San Mateo County, having constructed more than 25,000 homes. Today the Bohannon Organization is looking to transform a 16-acre parcel at the north end of the Bohannon Industrial Park (see page 69) near Highway 101 from a business district to a sustainable, energy-efficient, mixed-use community where a balance of homes, jobs, and retail will make better use of the land. (MPHA.)

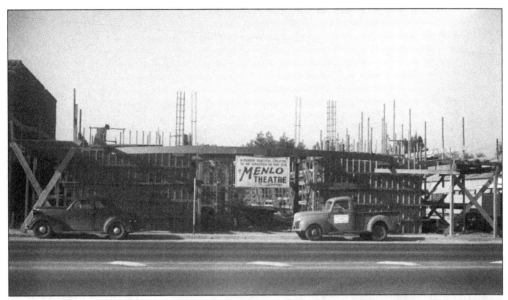

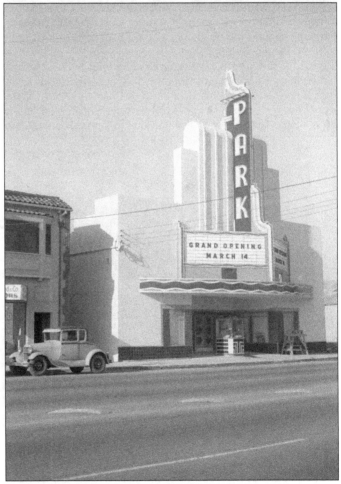

The Park Theater, which opened its doors in March 1947 as a vaudeville theater, was located at 1275 El Camino Real. This March 26, 1946, photograph shows the construction by Menlo Theater Company well underway. As movies became more popular, the theater was converted and became a local moviegoer's treasure. It boasted a beautiful Art Deco interior and comfortable seats that could accommodate more than 660 patrons. After falling onto hard times, the theater showed its last movie in 2002, and the building was demolished in April 2014. (Both, Reg McGovern.)

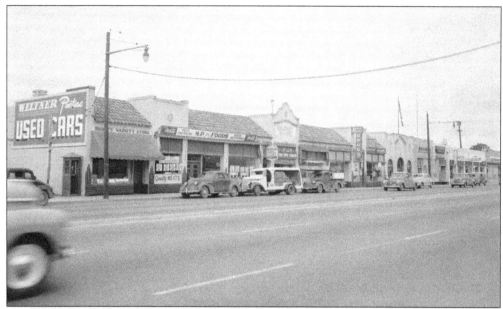

When this photograph of a strip of shops on El Camino Real was taken on April 14, 1948, Menlo Park's population was about 12,000, and the business community and retailers were responding to serve the growing populace. Two areas—the Belle Haven and Suburban Tracts—had been annexed to the city and accounted for more than 1,000 residents. The city's proximity to Stanford University was also a magnet for thousands of students seeking to live close to the school. Pictured here is the Maloney Building, a Bank of America branch, Menlo Drugs, and the Brune Variety store. Today the same strip of land between Oak Grove and Santa Cruz Avenues houses the Menlo Park Academy of Dance and the Sultana Restaurant. (Reg McGovern.)

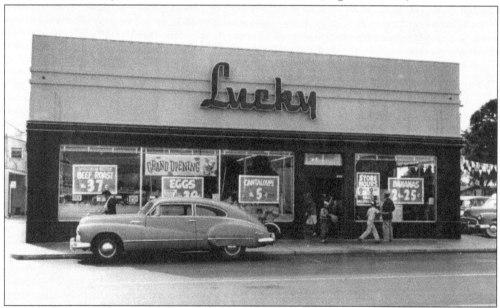

Lucky supermarkets opened at 633 Santa Cruz Avenue, between Johnston Lane and Doyle Street, one block off El Camino Real. This space was formerly occupied by the city's Safeway grocery, which had moved to its current location at 525 El Camino Real. (MPHA.)

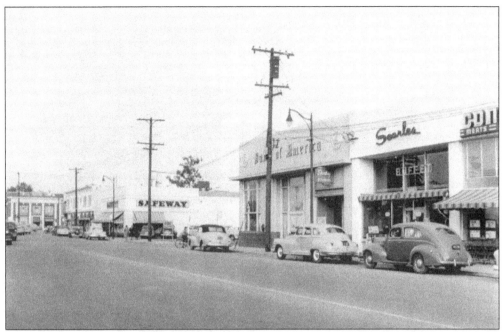

Here are two views of Santa Cruz Avenue, one from about 1950, above, with the brick bank building and former city hall visible on El Camino Real, Safeway at 633 Santa Cruz Avenue, Bank of America at 635, and Searles Buffett at 641 Santa Cruz Avenue. The lower photograph, shot by Elmo Hayden a decade later, shows the bank building, the Lucky store now in place of Safeway, Bank of America, Searles, and closer to the camera Joe Prein's Menlo Park Radio, more commonly referred to as Prein's Record Shop, at 705 Santa Cruz Avenue. (Above, MPHA; below, MPHA/EHC.)

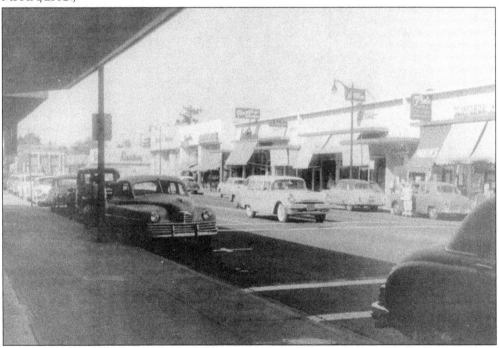

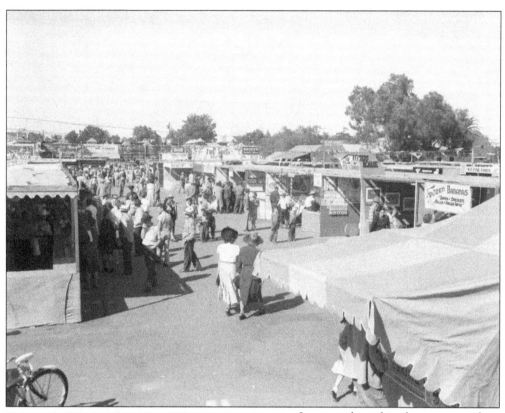

Its roots planted in the same era when California entered the Union, Menlo Park pulled out all the stops in June 1948 for a weeklong celebration of the state's centennial. The activities included the dedication of James Nealon Park, carnival rides and games, dance contests, a horse show, and circus acts. Local girl Tish Eder was selected queen and given the opportunity to visit Hollywood to appear on the *Queen for a Day* radio show. More than 100 peninsula and Bay Area businesses, civic groups, schools, and other organizations had exhibits at the plaza grounds, including Marquard's Drive-in, Cook's Seafood, Allied Arts, and Gibson Appliance, to name a few. Portraying the sheriff, S.W. Flaherty got into the fun of the event and the Old West spirit by putting the arm of the law on bank robber Lloyd Neumann. (Both, Reg McGovern.)

For two months before the centennial celebration, beards were sprouting on the faces of local men. The four contestants pictured here from left to right entered the contest for the reddest beard: Mr. Leslie, Phillip Bengo, Dominic Ryan, and Bernie McLaughlin. The winner of the whisker contest with the bushiest and blackest beard was John Fisher, whose prize was a razor, and Dominic Ryan took the prize for reddest beard. The climax of the week of celebration was a two-hour parade, horse show, and an appearance by nationally known singer Peggy Lee. The parade featured the first showing of the California centennial float, which was to be loaned to cities and counties holding centennial celebrations. An estimated 12,000 attended the opening day and 55,000 during the entire celebration. (Both, Kathleen Lorist Collection.)

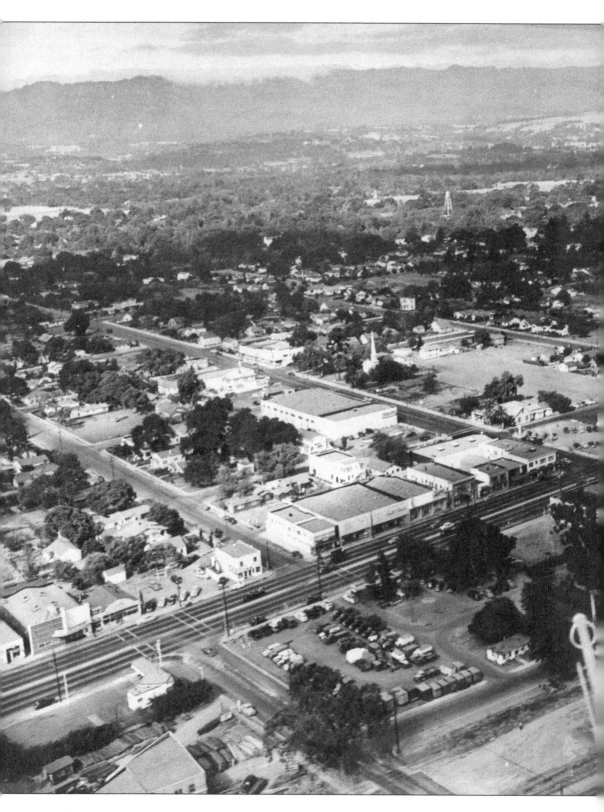

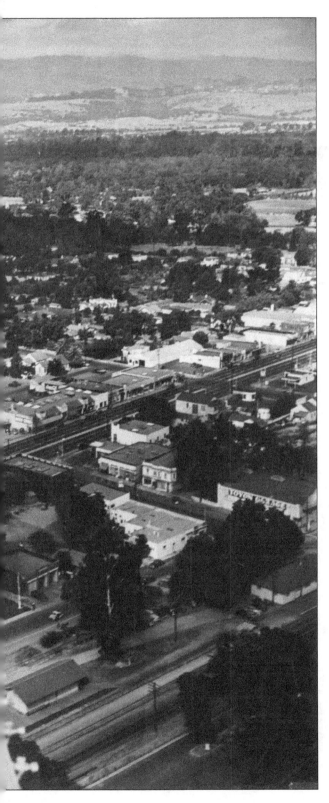

This aerial view was shot in the late 1940s by the indispensable recorder of Menlo Park progress Elmo Hayden, who was taken up by helicopter pioneer Stanley Hiller. The Southern Pacific freight depot is visible at the lower end of the photograph, and the roof of the baggage house, now the home of a model railroad club, is easily identifiable to the north. The freight depot was retired in 1958, and the baggage house was later moved to about where the freight depot stood. The realignment of the Ravenswood Avenue intersection at El Camino Real was still in the future. The parking lot and buildings occupy the site where Menlo Center was constructed in 1989. An automobile dealership was on the corner of Santa Cruz Avenue and El Camino Real, and in the center of the photograph, the spire of Menlo Park Presbyterian Church is visible. Off in the distance, the water tower of Sacred Heart School in Atherton can be seen. The water tower is still there. (Menlo Park Presbyterian Church Collection.)

This building at 630 Menlo Avenue may not look futuristic, but this first home for Little House was a model for what would become commonplace nationally: centers for the growing senior citizen population. Targeted to seniors aged 50 and over, the pioneering Little House later moved to a five-room bungalow at 930 Santa Cruz Avenue in 1951 and finally in 1954 into its present site at Nealon Park. Begun in 1949 with 12 members, Little House had grown to 300 by the time ground was broken for a permanent recreation center at Nealon Park. The visionary women of Peninsula Volunteers, Inc., focused on the needs of senior citizens decades before others did and launched this first suburban senior center in the western United States, raising funds for construction, programs, and services. (Above, MPHA; below, Reg McGovern.)

In 1955, the Menlo Park Chamber of Commerce assumed responsibility for bringing Santa from the North Pole. For about 40 years, the jolly old elf who played the role of Santa had been paid, but the chamber manager felt that it would be less commercial to seek out a volunteer. The chamber turned to Little House, and the seniors there obliged, as this December 13, 1955, photograph attests. (Reg McGovern.)

Amy Ann Sullivan, pictured here on July 22, 1948, was one of six children of Southern Pacific vice president Felix McGinnis, who purchased Fairwinds in 1928 as a summer estate. McGinnis brought a cable car and Pullman car to the property on Arbor Road adjoining Santa Cruz Avenue, and the McGinnis children and their friends played in them. The land was sold to the Archdiocese of San Francisco in 1948. (Reg McGovern.)

Taken on March 21, 1951, this photograph shows the 700 block of Santa Cruz Avenue under construction. Menlo Hardware, now Ace Hardware, was one of the anchor tenants. While the original building still stands today with the hardware store occupying the majority of the 700 block, all of the other original shops are gone. (Reg McGovern.)

In April 1954, for the 17th year, the Menlo Park Lions Club hosted boys chosen from Hillview, Encinal, and St. Joseph's Schools for the annual Boys Day Dinner. In addition to the banquet, the youngsters were able spend time with San Francisco 49ers stars such as lineman Art Michalik. Boys chosen to participate also spent time with local merchants and government officials. (Reg McGovern.)

From earliest days, amateur drama has been a popular pastime, planting the seeds for the Menlo Players Guild. The Church of the Nativity was often the venue for theatricals, such as this 1955 variety show called *Musical Portraits*, featuring a Floradora sextet. The church hall was transformed into a cabaret for the show. Pictured here are Mrs. Peter Bolich (left), Mrs. George Beal, and Art Hogan. (Reg McGovern.)

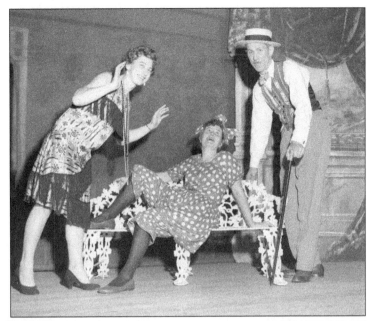

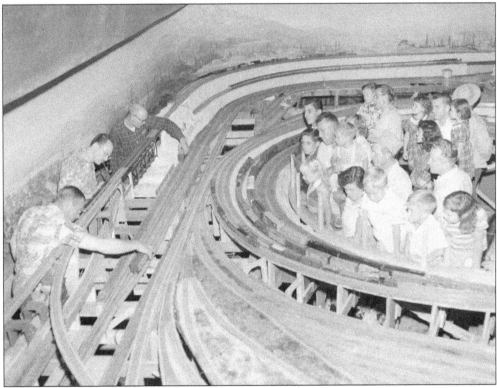

Organized in 1947, the West Bay Model Railroad Association set about building elaborate model layouts inside a former Southern Pacific baggage house south of the depot. Enthusiastic children and adults crowd around in this 1950 photograph to watch the railroad action. Since 2013, West Bay members have been working to update the old layouts with a two-level HO-scale model railroad designed to operate like a real railroad. (Reg McGovern.)

Lucelle's Dress Shop was located at 1001 El Camino Real. It was one of the premier dress shops for ladies and young girls in the Menlo Park area. Judging from the styles in the window, Lucelle's is ready for summer, but a spring rain has just washed the premises. (MPHA/EHC.)

Originally the Menlo Theater, this venue opened its doors on May 7, 1926, before the talkies made their debut, to show *King of the Turf*. The theater held that name for two decades until it was changed to the Guild Theater. During the Great Depression, in order to bring in patrons, the theater offered Country Store Days where dishes would be given away to the women that attended. In the late 1930s, 30 feet of the lobby had to be removed to accommodate the widening of El Camino Real. (Reg McGovern.)

Located at 1145 Merrill Street, this two-story home has had a varied past. It was once home to San Mateo County supervisor P.T. McEvoy, then real estate agent John H. Sullivan. It also served as the Menlo Funeral Home and then Lisa's Tea Treasures. The building is now the offices of attorney John C. Martin and Martin Wealth Management, which occupies the ground floor. (MPHA/EHC.)

Mike Bedwell came to work as assistant city manager in 1959 and was subsequently promoted to the top job, remaining until his retirement 25 years later. Genial and well liked, Bedwell provided a steady hand during a period of both growth and political tumult. The civic center complex's completion and the conversion of the Marsh Road landfill for a park were highlights of his career in Menlo Park. (MPHA.)

Since Leigh and Lillian Aldrich opened Menlo Florist in 1952, it has been a family affair. Their son Gary managed flower production at their ranch in Santa Cruz, while his brother Allan worked in the store. In the early 1990s, Allan and his wife, Leslie, bought the store at 780 Santa Cruz Avenue, working together until his retirement. Leslie runs what today is called Menlo Gift Bazaar. (Allan Aldrich.)

Looking west on Santa Cruz Avenue in this photograph from about 1971, the sign for the popular Walnut Tree restaurant on the northwest corner of El Camino Real can be seen at right. Bay View Federal Savings on the north side of Santa Cruz Avenue faces Bank of America on the south side. Notice that there are two lanes of traffic in each direction. (MPHA/EHC.)

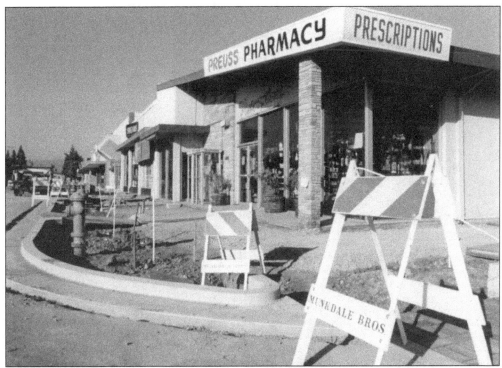

Orville Preuss founded Preuss Pharmacy about 1947. It sold cosmetics, greeting cards, jewelry, and gift items and was known for its personal service—even home delivery. John Celedon bought the business in 1999 and moved to this location at 844 Santa Cruz Avenue. When changing times made it difficult for community pharmacies to compete, Celedon sold Preuss to Safeway in 2009 and became a Safeway pharmacist. (John Celedon.)

Menlo Clock Works, located at 961 El Camino Real, opened its doors in 1981. Josef Landolt is pictured here adjusting the inner workings of a mantle clock at his workbench. The business is located adjacent to the Guild Theater in the building that was once occupied by Wo Sing Laundry. (MPHA/PTT.)

This building at 3207 Alameda de las Pulgas dates back 100 years or more and has functioned as a saloon, butcher shop, and market. Bob Wehab has been working at Country Corner delicatessen and market alongside his wife, Nadia, since 1992, and it remains a popular neighborhood spot. He had worked there briefly in 1974 and bought the business from his former employer. (Janet McGovern.)

Lutticken's deli, owned by Bob and Judy Lutticken, has been a neighborhood staple since 1981, serving up sandwiches, salads, desserts, and coffees at its 3535 Alameda de las Pulgas location. The deli has recently opened for dinner, calling the service "Lutticken After 5." The Luttickens also operate a deli on the Stanford campus, known by students as the CCSR Café, for the Center for Clinical Sciences Research, where the business occupies the first floor. This 1992 photograph shows Bob standing behind the counter of the original location. (MPHA/EHC.)

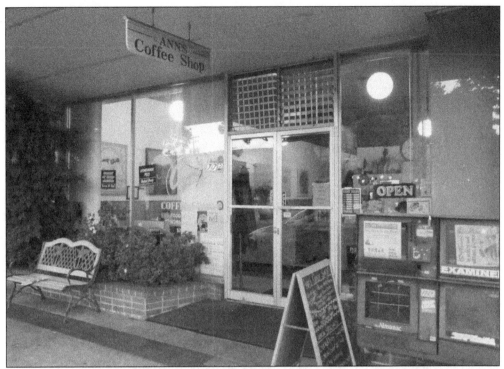

The namesake of the landmark Ann's Coffee Shop at 772 Santa Cruz Avenue was Ann Gilberg, who started in restaurant work at age 15. Opened first in Clifford's Pharmacy around 1946, Ann's specialized then—and does today—in authentic home cooking, including roasts, soups, hotcakes, and pies. The original Ann is pictured below (far left) when her bowling team competed in a tournament. Despite selling the business in 1982 and subsequent ownership changes, Ann's name, as well as the booths, counter, and furnishings, live on. Nicki Poulos, who has owned the business since 2008 with her son George Paplos, says many customers are third-generation patrons, and they do not want anything to change. "And I agree with them," she said. "Why change it if it works fine?" One chef, Eddie Mejia, has worked for every owner. (Above, Janet McGovern; below, Dick Gilberg.)

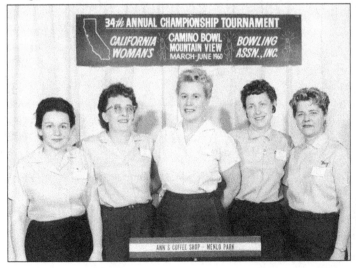

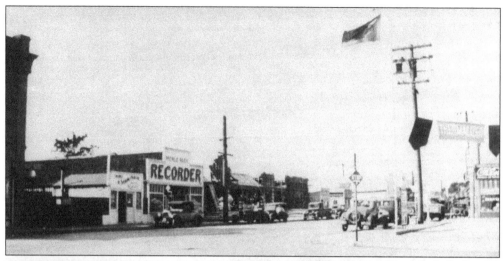

The *Menlo Park Recorder*, 1924–1990, changed names many times through its life, circulating as the *Menlo Park News*, *Menlo Park Gazette*, and lastly the *Menlo-Atherton Recorder*. The above 1934 photograph shows the building that housed the *Recorder* at 1047 El Camino Real, between Santa Cruz and Oak Grove Avenues. In 1962, the *Menlo Park Recorder* received a new printing press and was the first newspaper in the area to use an offset press. Shown here, from left to right, are head pressman Jackson DeBonnet, publisher Clarence A. "Cab" Burley, and Edna Crane Burchfield, inspecting the new printing press. (Both, MPHA.)

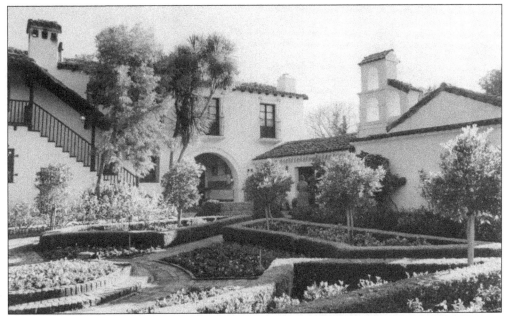

This beautiful setting is the home to the Allied Arts Guild of Menlo Park. Located on the former Jeff Murray estate at 75 Arbor Road and Cambridge Avenue, this 3.5-acre complex was purchased by Delight and Garfield Merner in 1929 "to provide a serene, beautiful place for artists." Ansel Adams was the official photographer and had one of the workshops. All profits from the artisan shops go to the Lucile Packard Children's Hospital. (MPHA.)

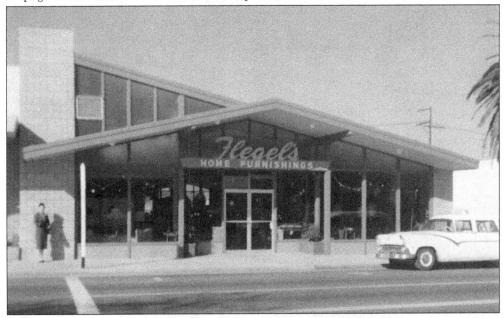

In 1954, Cleora and Arthur Flegel opened their first furniture store at 880 Santa Cruz Avenue. The original Flegel's Home Furnishings location, seen here in 1959, was consumed in a fire in the early 1960s, and the business was rebuilt in a larger, two-story building incorporating the lot next door at 870 Santa Cruz Avenue. The company, now run by second-generation owner Mark Flegel, offers top-of-the-line furniture as well as interior-design services. (Flegel family.)

Golden Shears barbershop at 814 Santa Cruz Avenue has been a downtown fixture since partners Lyndal Harris (photograph above, foreground) and Louis Arenas (left) opened it in 1963. Saying theirs was "the most complete barbershop on the Peninsula," the duo offered not just a $3 haircut but manicures, tinting, or a clay-pack facial too. The sole owner for about 40 years, Arenas proudly celebrated 50 years in business in 2014. (Above, Reg McGovern; left, Louis Arenas.)

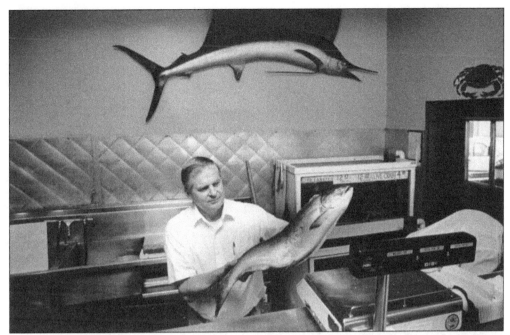

Cook's Seafood Restaurant and Market has been an icon in Menlo Park since 1928. Bob Cook, who was Menlo Park's second police officer, founded the restaurant. After Cook's retirement in the 1940s, he sold the business to Robert Rahe. After Rahe's death, his widow sold the business in 1963 to longtime employee Roy Crumrine, who started with Cook's at the age of 15 making $1 an hour as the dishwasher. Crumrine and his son Mike continue to run the thriving business today. (MPHA/PTT.)

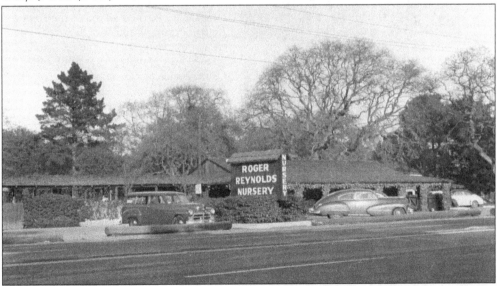

The founder of Roger Reynolds Nursery was a commercial printer who had to change careers in 1919 because he became allergic to printing ink. Reynolds purchased 18 pristine acres and opened a nursery, learning about horticulture by responding to customer questions. Reynolds later added a recreational park. The nursery closed in 2013, and the two acres at 133 Encinal Avenue that still remained were sold for development. (MPHA/EHC.)

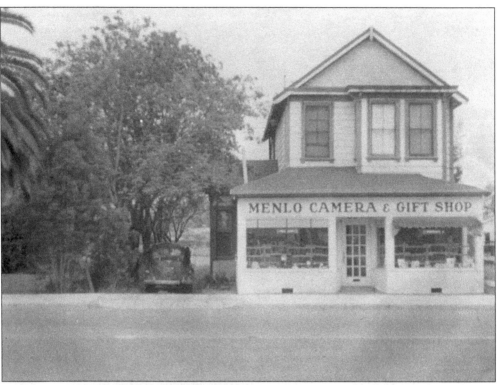

Though our greetings are in arrears
None the less are full of cheer—
Hope you had a "Snappy" Yule
And have a "Flashy" Year.

The Haydens

Jan. 1956

Elmo Hayden operated the city's most popular camera shop for half a century. Hayden was a highly decorated Army Air Forces pilot and served in the Pacific theater during World War II. After the war, he moved to Menlo Park and opened his original shop at 654 Santa Cruz Avenue, above, and was one of only four businesses on the street at the time. He recorded all major events in the city from 1947 to the early 1990s. Recalled for service during the Korean War, Hayden flew B-36 intercontinental bombers, one of the largest aircraft built up to that time. He then served in the reserves, retiring with the rank of colonel. The Hayden family was comfortable both behind and in front of the camera. On the left is the Hayden family holiday card from 1956 showing, from left to right, Hayden, Gayle, Cheryl, his wife, Carol, and Colleen Sue. (Both, MPHA.)

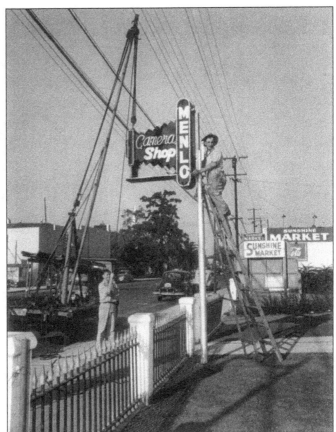

In 1951, Menlo Camera Shop moved down the street to 773 Santa Cruz Avenue. The shop's new sign attracted a lot of attention when it was lit, and the front lawn played host to many photography events for local amateur camera buffs. There was no shortage of fancy cars with pretty models having their photographs taken on sunny days. (Both, MPHA/EHC.)

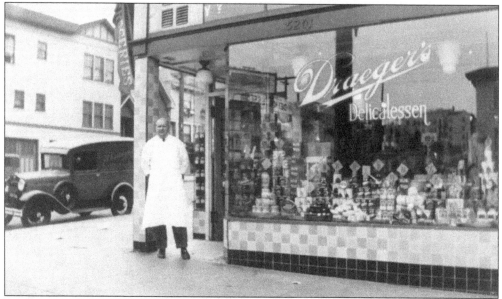

Draeger's Markets' roots reach back to this delicatessen at Seventh and Clement Streets in San Francisco, opened in 1925 by Prussian immigrant Gustave Draeger. From that first venture, the Draeger patriarch went on to build the largest market in the city by 1945. He leased it to his sons Frank and Gustave Jr., who opened a second store in San Mateo in 1949. (Draeger's Market.)

Frank Draeger stands outside the flagship Menlo Park market with the six of his 10 children who work in the family business. The store emerged a showplace after a complete renovation in 1991. With a two-story atrium, dramatic oak columns, and double the square footage, Draeger's offered a wider array of merchandise and features such as cooking classes taught by luminaries, including Julia Child and Jacques Pépin. (Draeger's Market.)

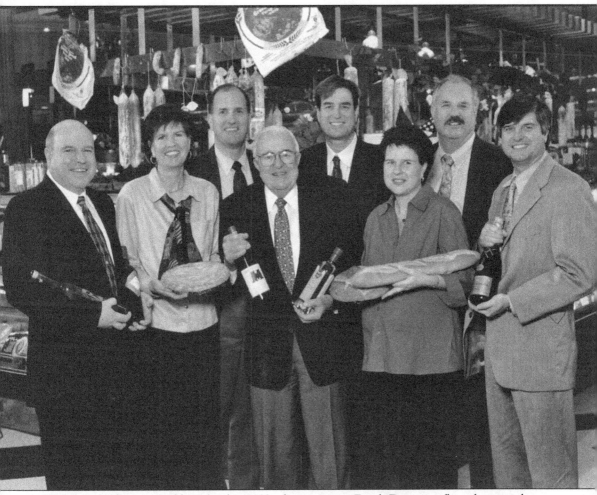

With his children around him for this 2003 advertisement, Frank Draeger reflected on another enjoyable decade operating the family-run grocery chain. Pictured here from left to right are Anthony, Mary Claire, Peter, Frank, James, Rebecca, John, and Richard. Through good and bad economic times, the Draeger's chain had grown to four stores and employed 384 people in 2014, including members of the fourth Draeger's generation. (Draeger's Market.)

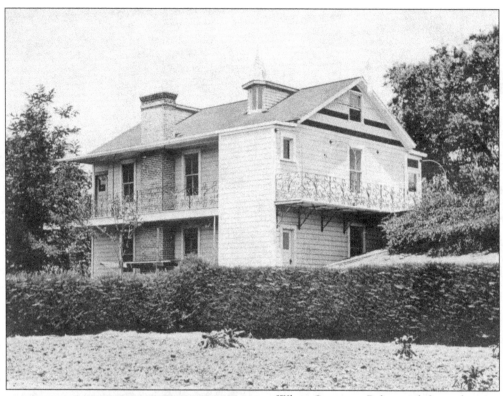

When Giovanni Beltramo left northern Italy to come to work in the vineyards of attorney John Doyle, he brought with him prized grape cuttings for transplant in America. After his arrival in 1880, Beltramo worked at Doyle's Cupertino vineyard and was promoted to foreman. By 1882, Beltramo had established his own wholesale-retail wine business on Ringwood Avenue. He and his wife, Maddalena, had a residence on Glenwood Avenue, operated a boardinghouse for fellow Italian immigrants (above), and sold wine. When Prohibition arrived in 1917, Giovanni limited operation to selling Isabella table grapes grown on the Glenwood property. During Prohibition, Giovanni's sons Alexander and Louis entered the construction business. The 1945 photograph on the left is of Alexander with his sons Daniel (left) and John. (Both, Beltramo's.)

Teresa Beltramo stands on the site at 241 El Camino Real where the Oasis Beer Garden is today. She and Alexander lived upstairs in the early 1930s and operated a beer garden–style restaurant until 1946, when he sold the business. Beltramo's Wines and Spirits has been at its present location at 1540 El Camino Real since 1935. In the photograph below, taken around 1941, Teresa stands outside with sons John (right) and Daniel. The brothers grew up in the business and since the 1960s have been the guiding forces behind Beltramo's, which has repeatedly been recognized in local polls and by the industry nationally as a premier wine store. Among the 25-plus employees at Beltramo's in 2014, five family members were involved in the business. (Both, Beltramo's.)

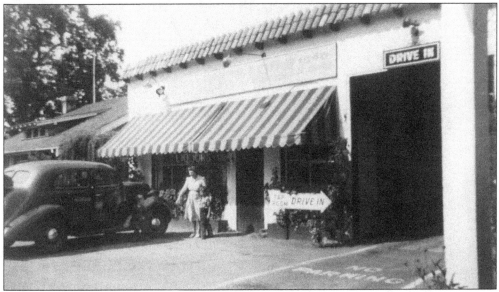

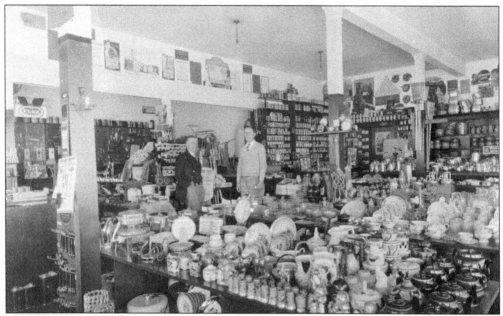

John William "Will" Ryan and Dominic Ryan are seen on the sales floor of the brothers' Menlo Park Hardware in April 1929, five years after it opened for business on the corner of El Camino Real and Santa Cruz Avenue. Notice the display of time-saving appliances in the foreground—waffle irons, toasters, and a hot plate—with everything from faucets to pitchforks in the background. (Kathleen Lorist Collection.)

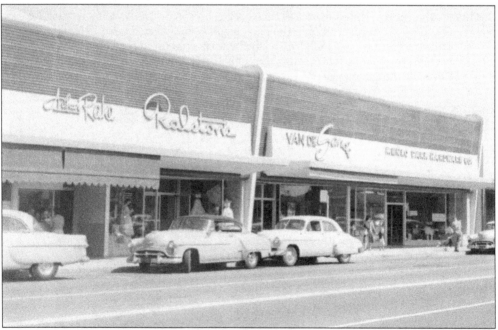

When the Menlo Park Plaza Shops were built on Santa Cruz Avenue, Menlo Park Hardware moved from its El Camino Real location in mid-1951. Parking lots behind the plaza enabled a greater flow of traffic in comparison to the El Camino Real site. The new store at 700 Santa Cruz Avenue is pictured here on June 3, 1954. (Kathleen Lorist Collection.)

Menlo Hardware's proximity to the offices of *Sunset* magazine gave the publication's editors a ready-made set for many product photographs. Here, Sheila Ryan and Dominic Ryan pose with new Covey Corporation Swinger coolers. Notice the *Sunset* magazine banner on the cooler boxes and the rack of *Sunset's* do-it-yourself instruction and travel books in the rack to the left. (Kathleen Lorist Collection.)

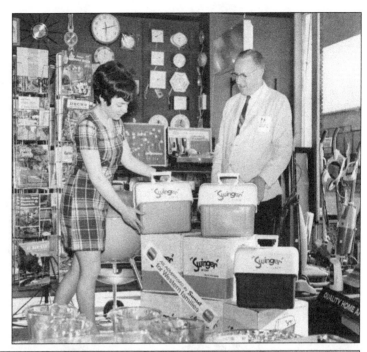

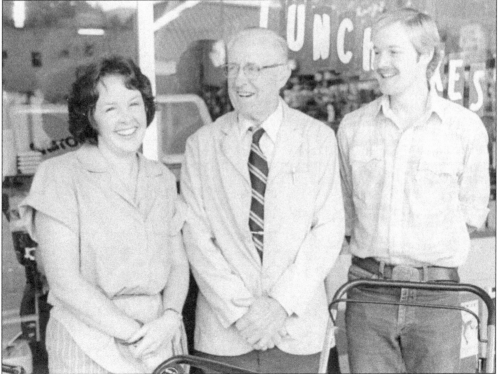

The family operated the hardware store for more than 80 years. Above, daughter Kathleen "Suzy" Ryan, cofounder Dominic Ryan, and son Bob Ryan pose for a photograph to mark Menlo Park Hardware's 75th anniversary in 1999. High rents at the peak of the dot-com boom forced the business to close in 2006. (Kathleen Lorist Collection.)

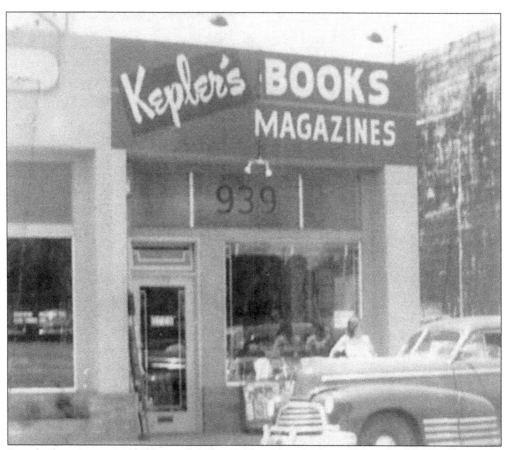

Paperbacks were new on the scene when Roy Kepler saw myriad possibilities for the low-cost format. A Bay Area leader in this democratization through bookstores, Kepler opened his bookstore in 1955 at 959 El Camino Real (above), next to the Guild Theater. Four years later, the store moved one block to 825 El Camino Real (below). (Both, MPHA.)

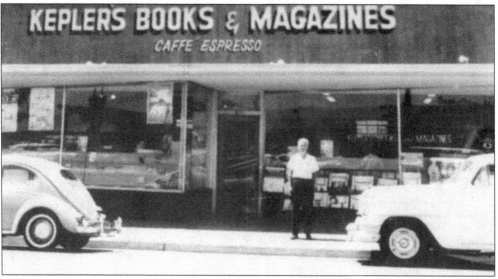

Roy Kepler (pictured) was a peace activist, and the store became a cultural and intellectual center during the 1960s and 1970s. In 1981, Kepler's landlord developed the block where the bookstore was located into a small center called Victoria Lane, and Kepler's relocated within it. In 1982, Kepler's son Clark took over store management. In the late 1980s, the property at 1010 El Camino Real (below) was razed and a new multistory retail and office complex built. In 1989, Kepler's relocated to the new center, becoming its anchor tenant. After Clark retired in 2007, Kepler's entered a transitional period and was restructured as a hybrid for-profit business and an educational and cultural nonprofit. (Right, MPHA/PTT/Gene Tupper; below, MPHA/PTT/Ellen Banner.)

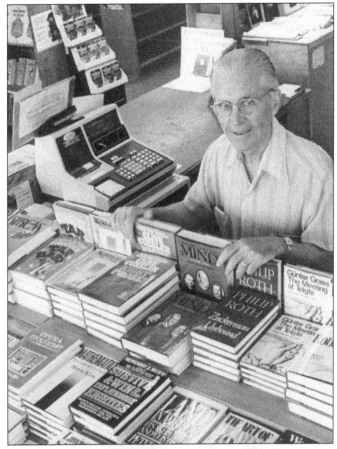

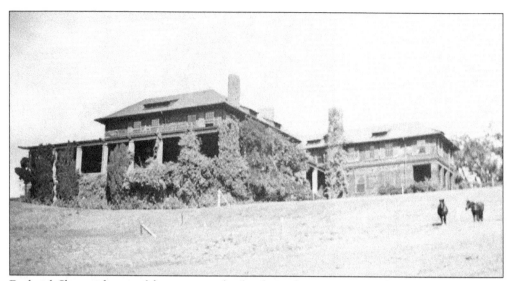

Frederick Sharon, the son of the pioneering banker, began buying up acreage between Menlo Avenue and Sand Hill Road in 1887 but did not do much to develop it until after the 1906 earthquake. He acquired more land and built Sharon Heights, a 32-room cottage with spectacular grounds that would become the site of westward development beginning in the 1960s. (MPHA.)

The namesake estate is just visible on the ridgeline above the Sharon Heights Golf and Country Club in this photograph taken about the time the clubhouse opened in 1962. About a dozen golfers interested in a private course in Menlo Park had begun meeting in 1960, and during the push to recruit 400 members, many parties were hosted at the mansion. (MPHA/EHC.)

Initially, 99 acres of rolling hills were purchased for Sharon Heights Golf and Country Club from Radin and McDonald Developers for $7,000 per acre, and an additional 14 acres were leased from Stanford University. The original land contained many stately oak trees, a number of which still grace the course today. This 1962 view of the first and ninth fairways showcases the wide vista, and more than 1,000 redwoods were planted on rather barren hills. The club was formally opened in June 1962, and an invitational tournament, today known as the Oak Leaf Invitational, became a tradition. In addition to its golf course, the club provided a venue for social events such as this 1968 fashion show. (Above, Sharon Heights Golf and Country Club; right, Reg McGovern.)

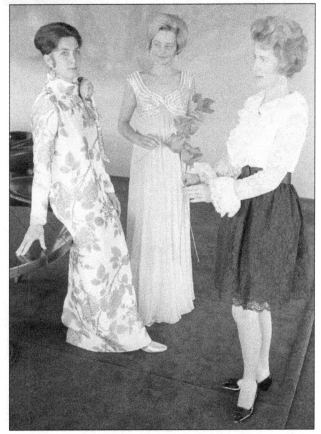

More development in the western part of the city followed, including the opening of the Sharon Heights Shopping Center in 1965. Construction began in 1969 on the first building at 3000 Sand Hill Road, an office complex developed by Thomas W. Ford and Phoenix Mutual Life Insurance Company. Built on a 16.5-acre site encircled by the Sharon Heights Golf and Country Club, the project embodied Ford's vision for creating attractive places to work, with open vistas, lush landscaping, and amenities nearby, including the Sundeck restaurant (now Restaurant 3000) for tenants and guests. Shown here in the early 1970s, 3000 Sand Hill Road became a West Coast hub for venture capital, as well as a home for high-technology companies. In 1987, Ford Land Company donated the funds to construct the clock tower that stands at the Menlo Park Caltrain Station. (Both, Ford Land Company.)

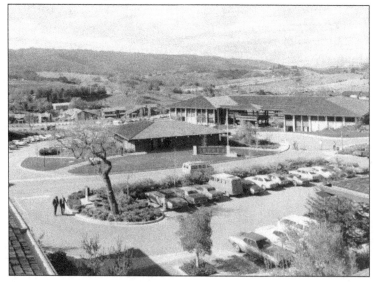

Buick, Chevrolet, Cadillac, Oldsmobile, Opel, Pontiac—El Camino Real had them all. Paul Polizzotto, seen here in July 1985, was sales manager for Shepard Cadillac. By 2005, most of the dealerships along El Camino Real had moved to new lots with adjacent freeway access or to new auto malls. In 2004, sales tax revenue from car dealers accounted for $692,000 out of the $1 million of transportation sales tax received by the City of Menlo Park. (MPHA/PTT/Renee Lynn.)

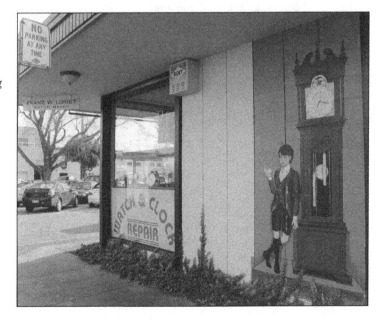

Franz W. Lorist is a fourth-generation European-trained watchmaker specializing in repair, maintenance, and restoration of fine timekeeping pieces of all varieties. Lorist opened Watch Maker at 651 Oak Grove Avenue in 1967, and he is well known for his unsurpassed talent in watchmaking. In 1984, Michael Day joined the shop, and he specializes in clocks and larger timepieces. (Betty S. Veronico.)

Brothers Jack and Steve Feldman opened Feldman's books at 1166 El Camino Real on June 2, 1996. Bibliophiles from around the San Francisco Bay Area make the trip to Menlo Park to peruse the Feldman's inventory of more than 50,000 used, out-of-print, and rare books. The store's building was constructed in 1905 and at one time was home to the Menlo French Laundry. (Betty S. Veronico.)

Café Borrone was first opened in Redwood City on Broadway in 1979 by Rose and Roy Borrone, and the eatery came to its current location on El Camino Real in Menlo Park a decade later. Rose created many of the items that are on the family-owned-and-operated café's menu using all fresh, local ingredients. Through the years, many of the Borrones' five children have worked at the café, giving the restaurant its friendly family atmosphere. To add to the ambience, Borrone's has live local musical talent playing jazz or easy-listening music on Friday nights. (Betty S. Veronico.)

Bill Larson opened his first pizza parlor in December 1959 at 1225 El Camino Real, and he is pictured here rolling out fresh dough in the front window. The pizza parlor was a couple of doors north of Oak Grove Avenue and is seen at the right in the lower photograph. In 1976, Larson's original location was torn down and replaced with an English-half-timber-architecture Round Table Pizza restaurant complete with the Knights of the Round Table motif. Later, the Ferrari repair shop at right was purchased and demolished to give the restaurant additional parking spaces. (Both, Bob Larson Collection.)

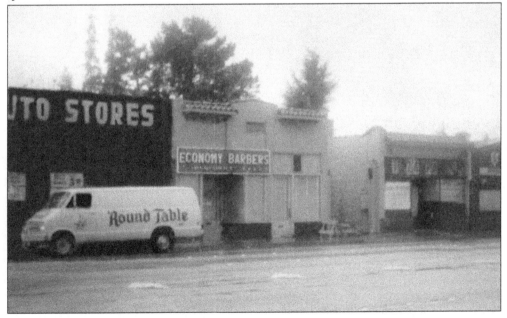

The Dutch Goose has been a local hangout since 1966. The original owner, Peter Eccles, purchased the restaurant, then named the Busy Bee, and promptly changed the name to the bar where he had his first beer, the Dutch Goose. Second owner Tom Moroney held the reins until 2005, when he sold the popular establishment to Greg Stern, who, despite old-timers' objections, had the audacity to add a fryer and include French fries on the menu. (Betty S. Veronico.)

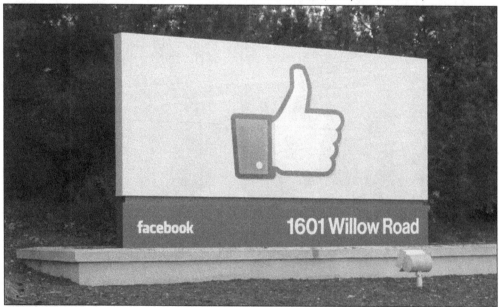

Facebook, the omnipresent social media network, has made its corporate home in Menlo Park at the corner of Bayfront Expressway and Willow Road since December 2011. More than 2,500 work at the headquarters. Today, a new 433,550-square-foot campus for an additional 3,000 employees is being built across the expressway on the former Raychem site. The company and its employees have become a generous philanthropic partner, supporting many local nonprofits through the Facebook Local Community Fund. (Facebook.)

Six

FRIENDSHIP CITY
GALWAY CITY, IRELAND

Many cities have sister cities, but few so closely bonded as Menlo Park and Galway City, Ireland. Having a relationship that dates back to the 1850s, and the fact that Menlo Park got its name from two men hailing from the Irish village of Menlough, establishes a kinship spanning more than a century. Urban growth has seen the village of Menlough become a suburb of today's Galway City.

On this side of the Atlantic Ocean, the friendship city project, known as Two Menlos, is a volunteer committee organized by the Menlo Park Historical Association under the leadership of Jym Clendenin, Fran Dehn, and Jim Lewis. And although there have been overtures between the two cities through the years, most notably by former mayor Peg Gunn in 1988, the friendship city project began to take shape in October 2012 when Galway resident Gerry Hanley came to Menlo Park to meet with members of the historical association. Hanley was deeply involved in the Menlo/Menlough connection, having met Gunn during her visit, and his home in Menlough is only steps away from the site where Dennis J. Oliver, one of the founding brothers-in-law of Menlo Park, once lived.

From Hanley's visit to California and tour of Menlo Park came a concerted effort to join the two cities in a formal agreement to facilitate academic, business, and cultural connections and exchanges between the two cities. A similar effort is underway in Galway City, and the Two Menlos volunteers are working to make connections here. The Menlo Park City Council agreed to proceed with the friendship agreement on August 27, 2013, with the intention of signing a formal agreement later that year.

Then-mayor of Galway City Councillor Pádraig Conneely traveled to Menlo Park in October 2013. In a ceremony held at the Stanford Park Hotel, Mayor Conneely and Menlo Park mayor Peter Ohtaki signed the friendship city agreement on the evening of October 17, 2013. The following month, Mayor Ohtaki spent the Thanksgiving holiday in Galway City, dedicating a plaque commemorating the relationship and cementing the foundation for future collaborations under the friendship city agreement.

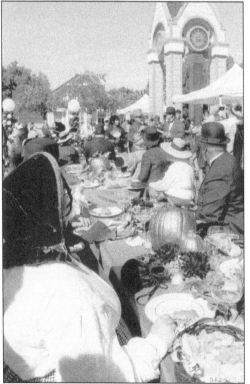

Councillor Pádraig Conneely, mayor of Galway City, Ireland, and Menlo Park mayor Peter Ohtaki met at the Stanford Park Hotel on October 17, 2013, to sign the friendship agreement between the two cities. (Kathleen Restaino.)

Saturday, October 19, 2013, dawned a beautiful day for the 150th anniversary and reenactment of the railroad's inaugural trip from San Francisco to Mayfield (now Palo Alto). Dignitaries, locals, many dressed in period costume, and a distinguished group from the friendship city, Galway, Ireland, including Mayor Conneely, attended the festivities that were held at the train depot. (Mary Knuckles.)

Mayor Conneely presents a photograph of the Menlough Castle in Galway, Ireland, to Caltrain Board chairman Ken Yeager. (Mary Knuckles.)

Mayor Conneely stands beside the plaque that was installed at 863 El Camino Real, near the corner of Live Oak Avenue. This was the approximate location of the arched gate erected by the first permanent settlers of the area, brothers-in-law Dennis Oliver and D.C. McGlynn. The gate bore the name Menlo Park. (Jim Lewis.)

In a reciprocal visit, Mayor Ohtaki traveled to Galway, Ireland, during the Thanksgiving weekend in 2013. Pictured here from left to right are Mayor Conneely, Mayor Ohtaki, and Dr. James J. Browne, president of National University of Ireland, Galway, at the Menlo Park Hotel, where Ohtaki was a guest. Ohtaki was given a VIP tour of Galway and Menlo Village, including the Galway castle, experienced the culture, and was shown old-fashioned Irish hospitality during his visit. (Peter Ohtaki.)

On Saturday, December 1, 2013, Menlo Park mayor Peter Ohtaki and Galway City mayor Pádraig Conneely unveiled a plaque at Menlo Pier in Galway, Ireland, to commemorate the connection between the two cities. (Peter Ohtaki.)

MAYORS OF MENLO PARK

12/6/1927–4/16/1928	Alfred E. Blake	12/6/1988–12/5/1989	Jan LaFetra
4/16/1928–4/16/1934	William H. Weeden	12/5/1989–12/4/1990	Gerald R. "Gerry" Grant
4/16/1934–4/9/1940	James E. Cooper	12/4/1990–12/3/1991	Ted I. Sorenson
4/9/1940–4/14/1942	Joseph Day	12/3/1991–12/1/1992	Jack Morris
Mayor for One Day	Hugo Day	12/1/1992–12/7/1993	Gail L. Slocum
4/14/1942–4/11/1944	Charles Oram	12/7/1993–12/6/1994	Robert E. McNamara
4/11/1944–10/23/1945	Donald Fischer	12/6/1994–12/5/1995	Raymond R. "Dee" Tolles
10/23/1945–4/28/1953	Charles P. Burgess	12/5/1995–12/3/1996	Robert N. Burmeister Jr.
4/28/1953–10/13/1954	Michael L. Belangie	12/3/1996–12/2/1997	Stephen M. Schmidt
10/13/1954–10/25/1955	Charles P. Burgess	12/2/1997–12/1/1998	Charles "Chuck" Kinney
10/25/1955–3/26/1957	George W. Ford	12/1/1998–12/7/1999	Paul Collacchi
3/26/1957–4/8/1969	William R. Lawson	12/7/1999–12/5/2000	Mary Jo Borak
4/8/1969–3/9/1076	Ira E. Bonde	12/5/2000–12/4/2001	Nicholas P. Jellins
3/9/2976–3/15/1977	James W. Calloway	12/4/2001–12/3/2002	Stephen M. Schmidt
3/15/1977–3/14/1978	Robert J. Stephens	12/3/2002–12/2/2003	Nicholas P. Jellins
3/14/1978–3/13/1979	James L. Bloch	12/2/2003–12/5/2004	Lee Duboc
3/13/1979–4/15/1980	Douglas W. Dupen	12/5/2004–12/6/2005	Mickie Winkler
4/15/1980–4/21/1981	Billy Ray White	12/6/2005–12/5/2006	Nicholas P. Jellins
4/21/1981–4/20/1982	Peg Gunn	12/5/2006–12/4/2007	Kelly Fergusson
4/20/1982–11/23/1982	Gerry Andeen	12/4/2007–12/2/2008	Andrew "Andy" Cohen
11/23/1982–11/15/1983	Billy Ray White	12/2/2008–12/1/2009	Heyward G. Robinson
11/15/1983–11/27/1984	Peg Gunn	12/1/2009–12/6/2011	Richard A. Cline
11/27/1984–11/19/1985	Jack Morris	12/6/2011–12/4/2012	Kirsten Keith
11/19/1985–12/2/1986	Billy Ray White	12/4/2012–12/3/2013	Peter I. Ohtaki
12/2/1986–11/10/1987	Ted I. Sorenson	12/3/2013–12/2/2014	Raymond D. Mueller
11/10/1987–12/6/1988	Calvin Jones	12/2/2014–Present	Catherine Carlton

Visit us at
arcadiapublishing.com

CPSIA information can be obtained
at www.ICGtesting.com
Printed in the USA
BVHW061353040319
541705BV00020B/1011/P